The
PEREGRINE
Sketchbook

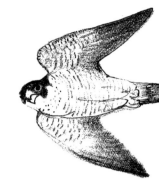

'The Peregrine is by far the finest bird we possess. Who can but admire its symmetry of form, who but revel in its superbly cut outline, full of latent vigour and agile strength, as poised disdainfully on some shelf or pinnacle far up a mighty ocean precipice or majestic mountain side, it surveys its surroundings with keenest of keen brown eyes? Nothing escapes its haughty penetrating gaze. It looks – as it rightly is – a very lord of the feathered creation.'

John Walpole-Bond,
1914

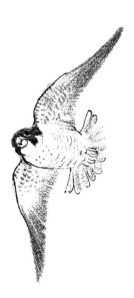

C.F. TUNNICLIFFE

The PEREGRINE
Sketchbook

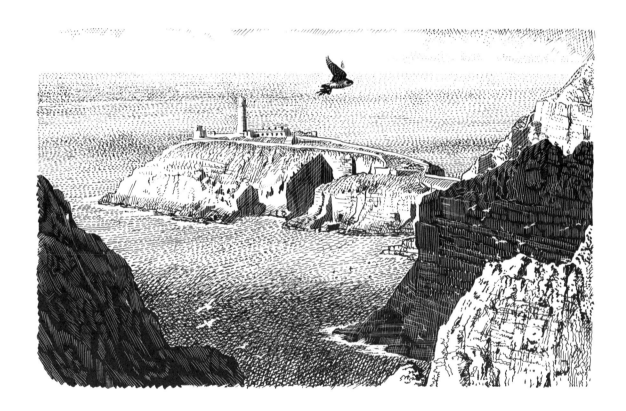

EXCELLENT PRESS

LONDON

Excellent Press
Metro House
5 Eastman Road
Acton
London W3 7YG

First published 1996

A CIP catalogue record for this book is available
from the British Library

ISBN 1 900318 02 4

Design and computer page make up by Penny Mills, Wrentham
Printed in Great Britain by CTD, Twickenham

Acknowledgements

Text and illustrations from *Shorelands Summer Diary*
and *My Country Book* and illustrations from Charles
Tunnicliffe's sketchbook are reproduced by per-
mission of the executors of the Tunnicliffe Estate.

Photography of the sketchbook was authorised
through the co-operation of the Oriel Ynys Môn,
Anglesey.

CONTENTS

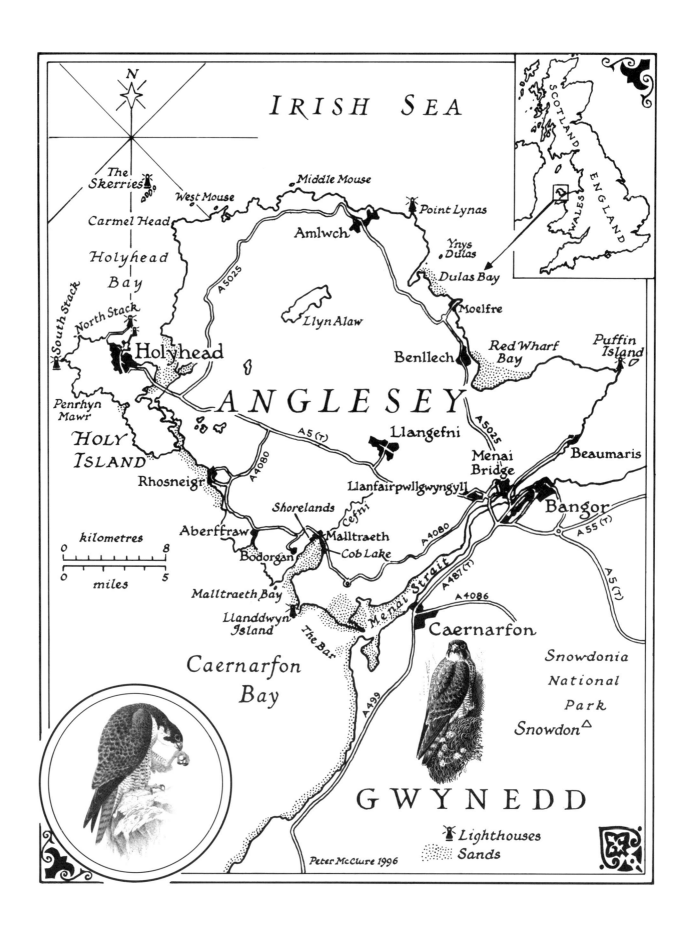

IRISH SEA

The Skerries

West Mouse

Middle Mouse

Point Lynas

Carmel Head

Amlwch

Ynys Dulas

Holyhead Bay

Dulas Bay

Moelfre

South Stack

North Stack

Llyn Alaw

Red Wharf Bay

Puffin Island

Holyhead

Benllech

Penrhyn Mawr

ANGLESEY

HOLY ISLAND

Llangefni

Menai Bridge

Beaumaris

Rhosneigr

Llanfairpwllgwyngyll

Bangor

Shorelands

Cefni

kilometres

0 8

Aberffraw

Malltraeth

Cob Lake

Bodorgan

0 5

miles

Malltraeth Bay

Menai Strait

Llanddwyn Island

The Bar

Caernarfon

Caernarfon Bay

Snowdonia National Park

Snowdon △

GWYNEDD

Lighthouses
Sands

SCOTLAND
ENGLAND
WALES

A5025 A5 (T) A4080 A5025 A55 (T) A487 (T) A4086 A499 A5 (T)

Peter McClure 1996

'From the time when man first scratched images on bone and rock, artists have, in a multitude of different ways, depicted birds, whose power to leave the earth at will and to speed through the air has ever aroused the wonder and envy of humans, and has also been responsible for many legends and superstitions: for, however familiar we are with birds, they never seem to lose their strangeness. They are a form of life quite unique – very different from earth-bound man and animals, yet having points of similarity with them which only serve to accentuate this difference. In the process of evolution they have become perfectly adapted to that mode of life which is necessary for their survival, and this adaptation has brought in its train much beauty, offering endless variety of subject matter for the artist.

The quality of this beauty is difficult to define, but, to me, it has a great affinity with that of flowers. It is of the bird, and does not depend on any special condition, excepting that of light, for its revelation.'

Charles Tunnicliffe

Bird Portraiture

INTRODUCTION

by
Robert Gillmor

IT WAS HENRY WILLIAMSON WHO FIRST fired Charles Tunnicliffe's passion for Peregrines. Following their collaboration over Williamson's masterpiece *Tarka the Otter* , the writer invited Tunnicliffe to illustrate his new book *The Peregrine's Saga* in 1933.

At that early stage in his career, birds had not featured much in Tunnicliffe's work. He needed to gain first hand knowledge of the Peregrine and so visited Avebury in Wiltshire where members of a falconry club had assembled to fly their hawks over the wide landscape of Salisbury Plain. Tunnicliffe studied the birds at close quarters as they rested and went with the falconers to observe and sketch the falcons 'trying their young wings against the wily rook' away over the Downs.

This visit made a deep impression on him. Ten years later, in the first of his own books, he recorded:

> 'I shall never forget the thrill I had at the first sight of those birds, all feather-perfect and fighting fit. There sat the devilishly fierce Goshawks and sparrowhawks, side by side with the dark-eyed haughty Peregrines, while in another enclosure were the dainty Merlins, the little falcons of my own east Cheshire and Derbyshire moorlands.'

> *My Country Book*

It was a thrill which endured for the rest of his life. A couple of years later, on Iona, in the Hebrides, he was watching and drawing birds to the exclusion of almost everything else. In his own words:

> 'Much of my time there, when not occupied in gazing at land and sea, was spent peering through field glasses at birds, many of which visited Iona on their migration flight. Birds among this rocky landscape seemed doubly attractive, everything washed so clean, birds so immaculate, and distances so wonderful that I never wanted to leave Iona.

> 'This visit, I think, was the real start of serious bird study, for after that I concentrated more and more on the birds of my native countryside and especially those of the Cheshire meres.'

By the late 1930s he was filling the pages of his sketchbooks with studies of bird life as he came to realise how birds could provide him with endless subjects for picture-making. His characteristic personal style was developing, showing a strong feeling for design and a delight in the decorative patterns to be found in natural forms. These pictorial elements were allied to fine draughtsmanship and a confident technique both in line and watercolour.

Charles and his wife Winifred, also an artist, came to live on Anglesey in 1947. She shared his enthusiasm for field study and accompanied him on countless birding forays from their new home on the Cefni estuary. The house was called 'Shorelands'. In 1952 Tunnicliffe immortalised it in his masterpiece *Shorelands Summer Diary*, a vibrantly illustrated account of Anglesey and its birds.

The sketchbooks from these early years at Shorelands contain some of Tunnicliffe's finest drawings. They were usually made in the studio after a field trip with

Winifred. He would rely on his formidable visual memory to recreate the day's observations, using his pencil sketches and notes made in the field as a reminder.

It was on one of these field trips that Tunnicliffe came upon the Peregrines. Towards the end of May 1948 he drove to the cliffs of South Stack in the north west of the island to observe the seabird colonies crowding the ledges above the lighthouse. His diary vividly records his excitement when a sweep of the field glasses along a 'garden of rock plants' suddenly revealed a nesting Peregrine 'sitting cosily in a niche surrounded by sea-pinks'. He was reluctant to leave and vowed to return soon. Return he did, three days later, and then regularly throughout the summer to check on the development of the young, the behaviour of the adults and the fledging of the eyesses until they finally left the cliffs in mid August.

To have discovered these magnificent birds on his doorstep was a Godsend for Charles Tunnicliffe and he took full advantage of it. Each diary account of his visits begins with a sentence revealing his burning interest to be back at the eyrie. The sketches and paintings reproduced here reflect the passion of his response to the Peregrines. For a bird artist at any period the Peregrine has a special fascination, and more so perhaps for Tunnicliffe during the years immediately after the war, when the Peregrine population had been decimated by action to protect the carrier pigeon, a falcon's favourite food.

Tunnicliffe's descriptions of the birds are as revealing as his paintings in indicating his attitude to these handsome predators:

> 'She looked wonderful in her wild garden: her trim, strong shape with its spotted chest, barred breast and flanks, and wide, dark yellow-ringed eyes had found a perfect setting.'

Here on the high cliffs above a wide sweep of sea the artist found his most compelling subject. He was inspired to produce the series of 26 colour sketches which must rank among his best work. Many of these studies became the reference points for large scale watercolours, and for the illustrations in *Shorelands Summer Diary*, all reproduced here from the original scraperboards.

In the art of scraperboard illustration Tunnicliffe was a master. His earliest book illustrations had been wood engravings, but these are slow work and hard on the eyes. Scraperboard is quick and simple to use, reproducing well on a variety of papers. A thin board is coated with specially prepared china clay, like a coating of polished enamel. At its simplest, the artist draws with pen or brush in black Indian ink which when dry can be scraped with a sharp tool to expose the white undercoating. Tunnicliffe used this technique throughout his post war career. When commercial scraperboard became difficult to obtain, he made his own.

For this book I have selected all the passages relating to Peregrines from *Shorelands Summer Diary* and placed them alongside the colour sketches. Now, for the first time, we have Tunnicliffe's own Peregrine's saga in both words and pictures, made during that memorable summer on Anglesey, the inspiring island where he continued to practise his art for a further quarter century, fulfilled and content.

Reading
March 1996

The PEREGRINE SKETCHES

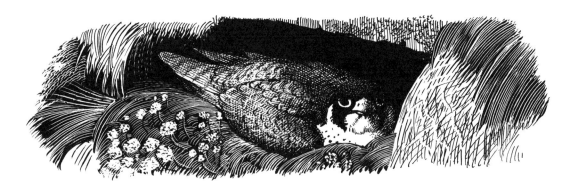

MAY 29TH

At four o'clock this afternoon we called at the school on the ridge, and picking up Wack and Margot we made our way to Holyhead, and beyond that strange place to the great cliffs of South Stack intent on Guillemots, Razorbills, and Puffins. When we arrived the fog signal was sounding, a sonorous full-throated note terminated by a deep thud which echoed along the cliffs and over the water into the mist. Later it cleared and the foghorn ceased, much to our relief. Leaving the car on the road we made our way down the headland to a point where we could see the rocky shelves on which the birds nested, and were not disappointed, for there they were in hundreds, making a nice compact little colony with Guillemots, as usual, crowded together, and Razorbills more exclusive and much less congested. My glasses wandered nearer, to a cliff on whose face wind and weather had worn a series of rough, huge steps. On these a garden of rock plants grew, especially sea-pinks and white campions, and it was while my glasses examined these colourful terraces that they came upon the grey-plumaged back of a bird, sitting cosily in a niche surrounded by sea-pinks. In great excitement I said, "I've got a Peregrine on its nest." W. and our two friends were all agog and presently found the patch of grey which was the bird.

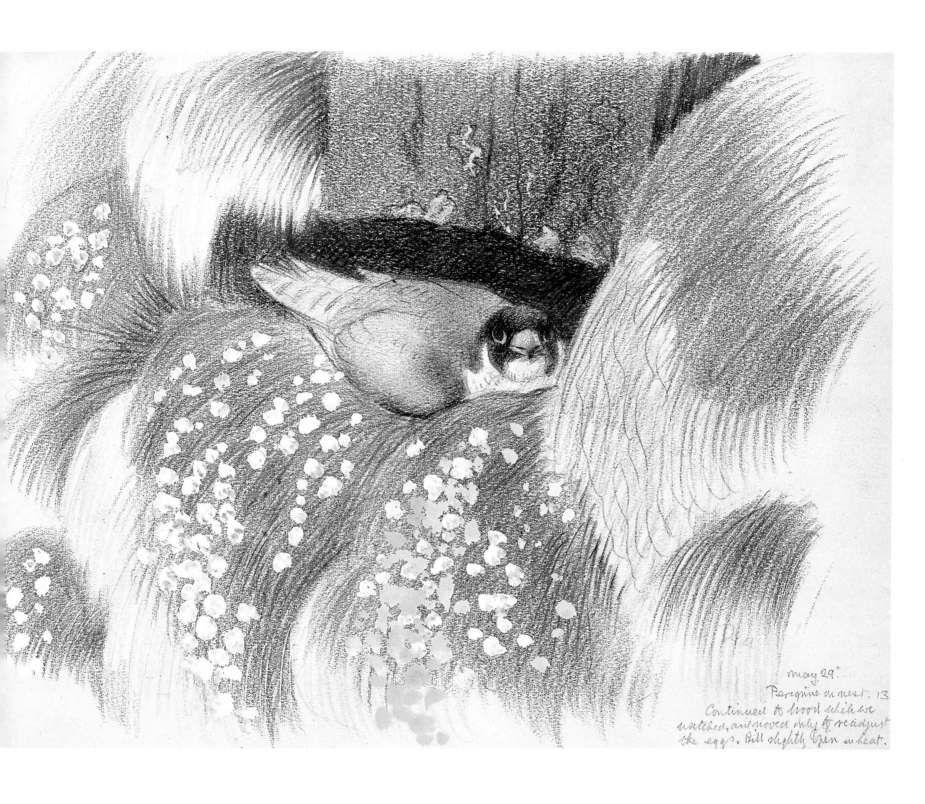

May 29.
Peregrine on nest. 13
Continued to brood while we
watched, and moved only to readjust
the eggs. Bill slightly open in heat.

With the naked eye it was next to impossible to see it. I lost interest in Razorbills and Guillemots for the time being, and could hardly eat sandwiches because of the Peregrine. There she brooded (it was the Falcon if colour and size were any indication) with beak slightly open, unperturbed and even sleepy, for it was a very warm day and the sun was shining full on her. In my previous experience of Peregrines, the birds had always flown up and circled round calling shrilly, but with this bird there was none of that; she sat on, and roused only to raise herself and to make whatever it was under her more comfortable. She seemed to be turning eggs but we could not be sure. At long last I was dragged away to see close-ups of Razorbills and Guillemots and, from the steps which descend the cliff to the lighthouse there were some remarkable chances to study the birds intimately. Laying had not really begun yet for we saw but one egg, a beautiful blue one by the side of a Guillemot. But all the time I was thinking of the Peregrine and presently, after watching Puffins swimming below, we returned and Wack and I went down the headland to our vantage point for another look. The falcon still sat there with hardly any change in her position. Reluctantly I said good night to the quietest Peregrine I had ever met and vowed to return soon.

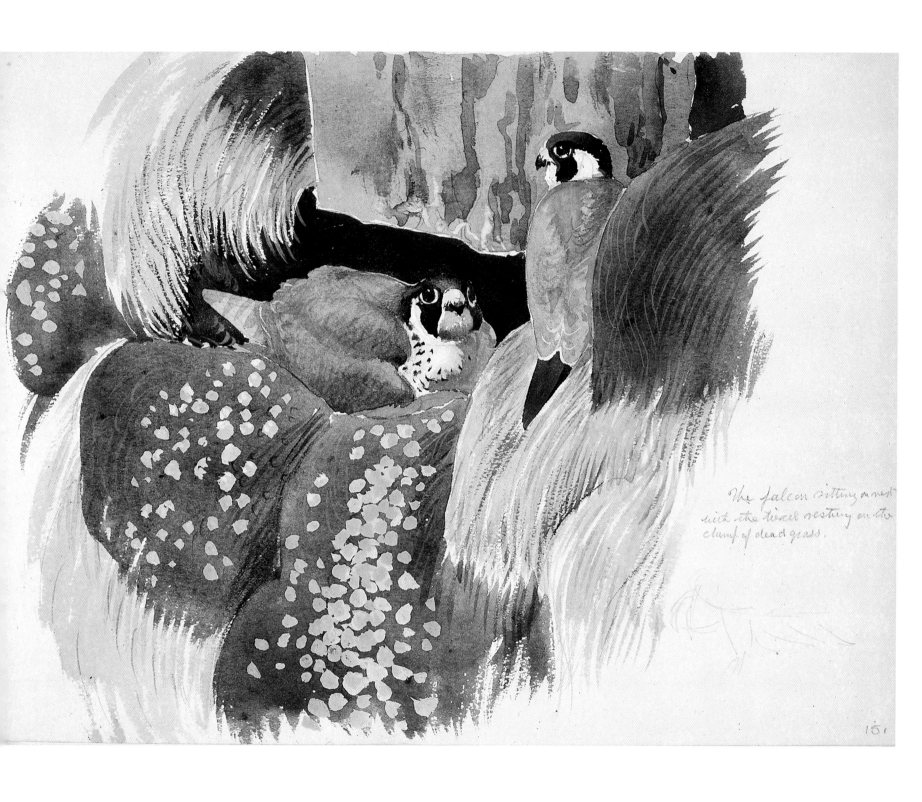

The falcon sitting on nest
with the tiercel resting on the
clump of dead grass.

15/

19

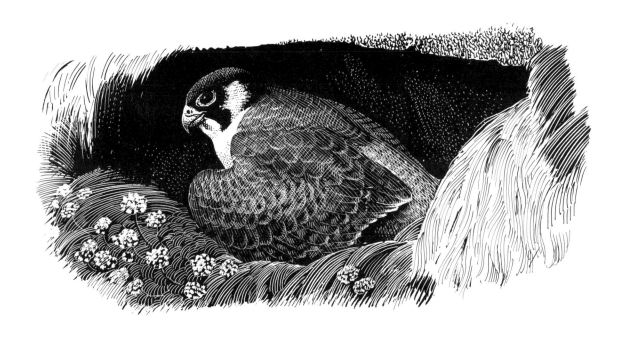

JUNE 1st

Soon after three o'clock this afternoon W. and I were again on the cliff top at South Stack armed with a telescope as well as field-glasses. There was a Peregrine, but this time it was a smaller and a bluer bird that was brooding, obviously the Tiercel – male. He sat with his head pointing to the sea and his tail against the rock and, but for a casual, occasional glance, was no more worried by our presence than was the falcon on our previous visit. The tiercel brooded and appeared to be resting on wings which were lowered and held away from the body. Sometimes he bent his head and, by his movements, I suspected that he was covering young. At short intervals the bird raised itself slightly to shuffle down into an easier position. The telescope revealed every lovely detail of head, back, and fore-wing. After we had been watching some time I caught a glimpse of a dark shape flashing into the cliff and, moving the glass, saw the falcon swoop up and perch six feet from the nest on a shoulder of rock on which sea-pink and white campion were blooming. She looked wonderful in her wild garden; her trim, strong shape with its spotted chest, barred breast and flanks, and wide, dark, yellow-ringed eyes had found a perfect setting.

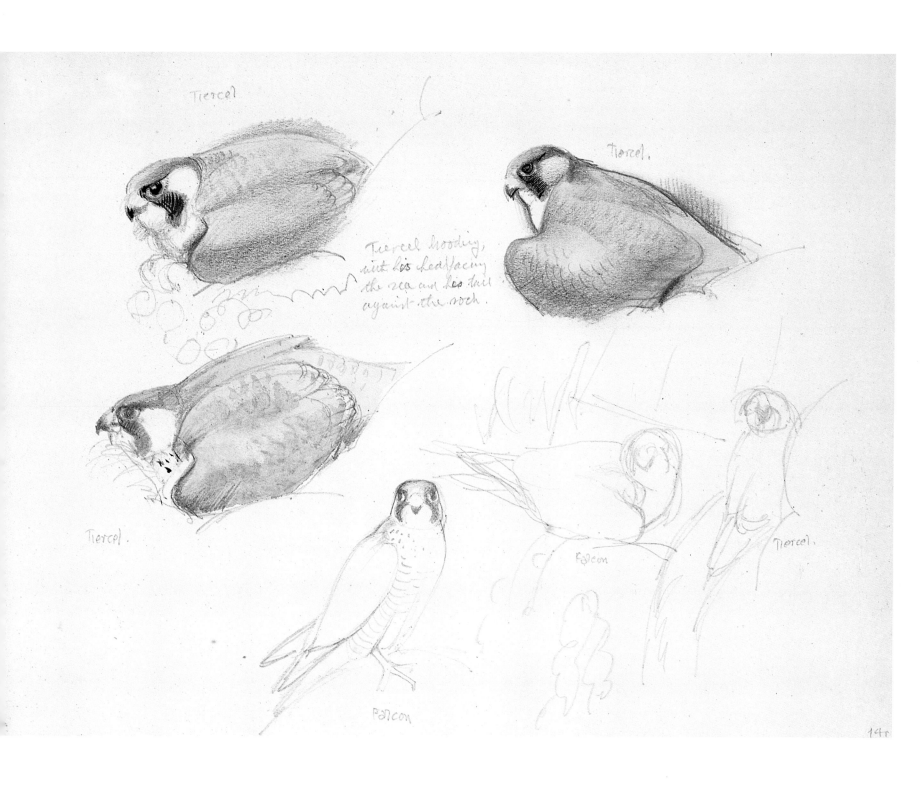

Tiercel

Tiercel.

Tiercel hooding,
with his head facing
the sea and his tail
against the rock.

Tiercel.

Falcon

Tiercel.

Falcon

As she gazed at us her eyes were not fierce, indeed she had almost a mild expression. But she was very dignified. People coming down the headland path caused her to leave her perch, and without a sound she slipped away round the cliff. Then we saw that the brooding tiercel was shuffling uneasily and, suddenly, he stood up and flickered away from the nest. Above its edge we saw the tiny white, swaying head and neck of a chick.

Only a few moments elapsed before the falcon appeared at the nest side. She gazed intently at the chick, then at us, and finally shuffled over the nest to brood. She was just settling down for what looked like a quiet doze when the tiercel, mobbed by an angry Herring Gull, shot into the cliff and came to rest near the nest side. His blue back was turned towards us, but he twisted his head round to keep an eye on us, and did not move from this position while he rested there. Falcon and tiercel remained there long enough for me to make a rough drawing of them and their environment. Suddenly the tiercel began to call, a long whining note which seemed to be directed at the falcon for she roused and regarded him intently. He left his resting place and glided away, and soon the falcon followed.

The hollow of the nest was fairly deep, but a careful scrutiny revealed only the one tiny chick. A dark shape flashed downwards past the lens of the telescope and, a moment afterwards, the falcon appeared between our cliff and the nesting cliff with something held dangling in her claw. We could not identify her burden, but it certainly was not feathered for, when she alighted at the nest and began to tear at the prey, no feathers floated away. It may have been a vole snatched from a grassy shoulder of the cliff below us. The falcon began to feed the chick, tearing minute fragments from her victim and reaching into the nest to the white swaying head. Sometimes, in her exertions, she slipped half into the nest. Eventually, the chick appearing satisfied, she swallowed the remainder of the prey herself and, with a final look round, settled down to brood. The tiercel did not appear again while we were on the cliff.

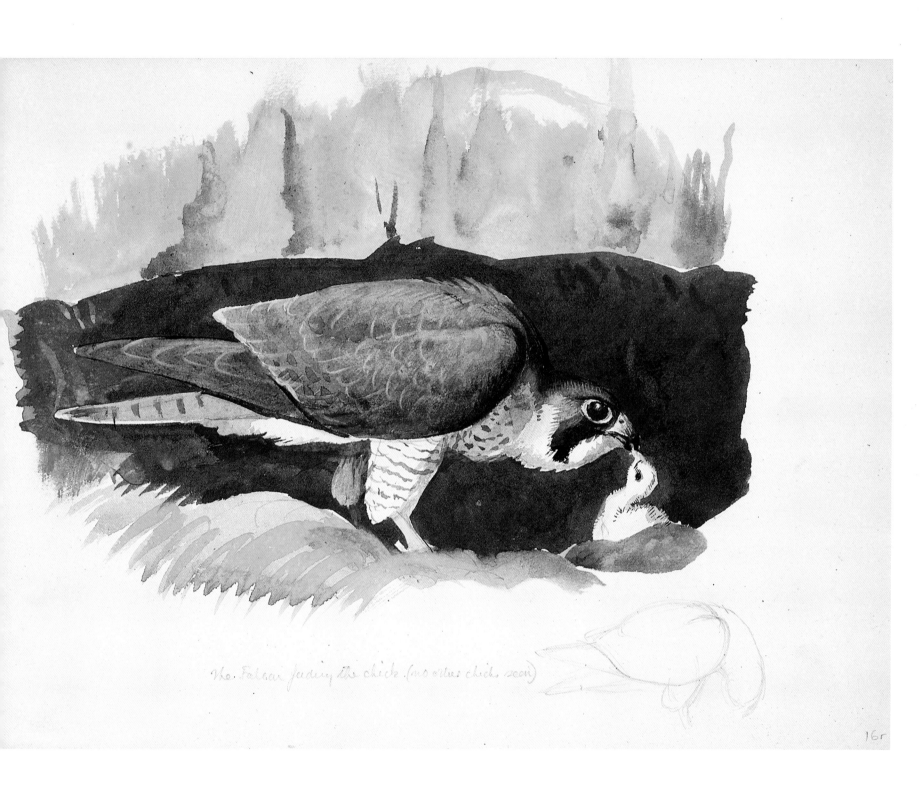

The Falcon feeding the chick (no other chicks seen)

16r

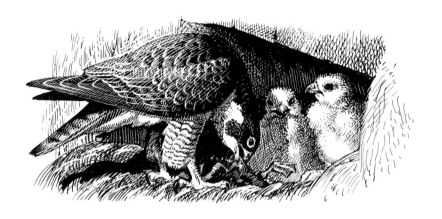

JUNE 19th

I felt that I must make an effort to visit the Peregrines on South Stack cliffs so, after working indoors all morning, I was glad to be, by mid-afternoon, on the flowery edge of the great headland. My pleasure was increased when I focused the glasses on the Peregrine's nest, for there was the falcon, in a good light, feeding two well-grown nestlings from a gory mess held under her talons. She glared across at me for several seconds, then bent her beautiful head and neck and resumed her vigorous pulling, straining against the resistance of her steel-strong legs to tear fragments of flesh from the corpse, which she gave to the young birds. Soon they appeared satisfied, and the falcon, changing her position so that she faced outwards, moved her prey which I now identified as a Puffin. Its orange legs stuck up from the torn body and a few feathers floated on to the growth of sea-pinks at the nest edge which was now untidy and streaked with white. The falcon stood gazing seawards, her own crop full and bulging, then, gripping the remains of the Puffin, she left the nest and sailed down the cliff with the prey dangling from one foot. She disappeared below the edge of the cliff on which I was sitting and I turned my attention to the two nestlings which were moving aimlessly about the nest hollow. One was considerably larger than the other; both were still covered with grey-white down but the beginnings of feathers could be discerned at the centre breast and the wing edges. Presently one staggered to the edge of the nest, turned its 'tail' seawards, and evacuated in a white jet over the edge.

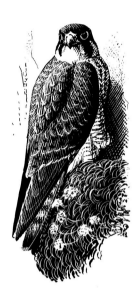

My gaze, wandering over the area of cliff near the nest, discovered the falcon perching quietly on a beautiful clump of sea-pink about seven feet from the nest. I had not seen her return to the cliff. She looked very comfortable, matronly, and dignified as she sat there. Presently her eyes half-closed, but she soon roused, lifted one foot and, with her bill, tried to clear away the blood and feathers which adhered to her toes. She was only partially successful in this and, becoming bored with her efforts and feeling the heat of the sun, which was beating full on her back, she walked awkwardly over the sea-pink and nearer to the cliff face where a jutting rock threw a shadow. Here she settled and was just going off into, what appeared, a quiet doze when the scene was suddenly transformed. The tiercel arrived with something in his claws – it seemed to be a mouse or vole – and laid it, pale underside uppermost, on the brown earthy cushion inside the sea-pink border. This brought such a yelping and a chattering from the falcon, answered just as shrilly by the tiercel, that, for a moment, the calls of the Peregrines competed with those of gulls and guillemots. Then there was a tussle and a flurry of wings and, next moment, the falcon was away with the tiercel's catch dangling in her foot. She carried it away in the same direction as she had taken with the Puffin remains, leaving the tiercel resting on his tail with his legs and feet spread out before him, and with a dazed expression about him as if he were trying to recollect just what had happened to him. He remained in this 'spread-eagle' pose for some minutes.

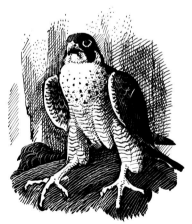

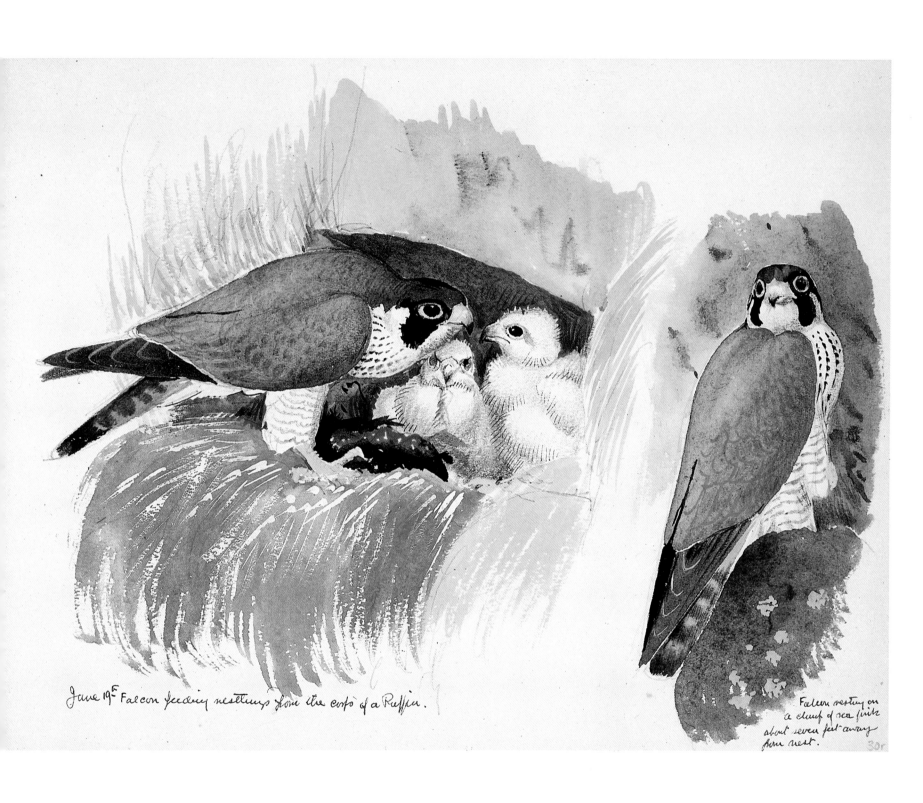

June 19ᵗ Falcon feeding nestlings from the corps of a Puffin.

Falcon resting on a clump of sea pink about seven feet away from nest.

30r

27

Presently the falcon having disposed of the tiercel's capture, returned to a perch on a withered clump of sea-pink near him. The tiercel, now more composed, gathered himself into a more dignified attitude and rested on the flat shelf of earth with his back to his mate. She ignored him and soon had settled herself, fluffing out her flank feathers and bringing up her right foot under them, letting her weight settle on to her left foot. There the tiercel and falcon rested, handsome and beautiful, and, but for occasional quick turns of their heads, did not move again while I watched.

Turning again to the nest I saw that the hot sun was causing the nestlings to pant, their bills slightly open. They moved restlessly about the nest and finally both huddled into a corner where there was a little shade, and slept.

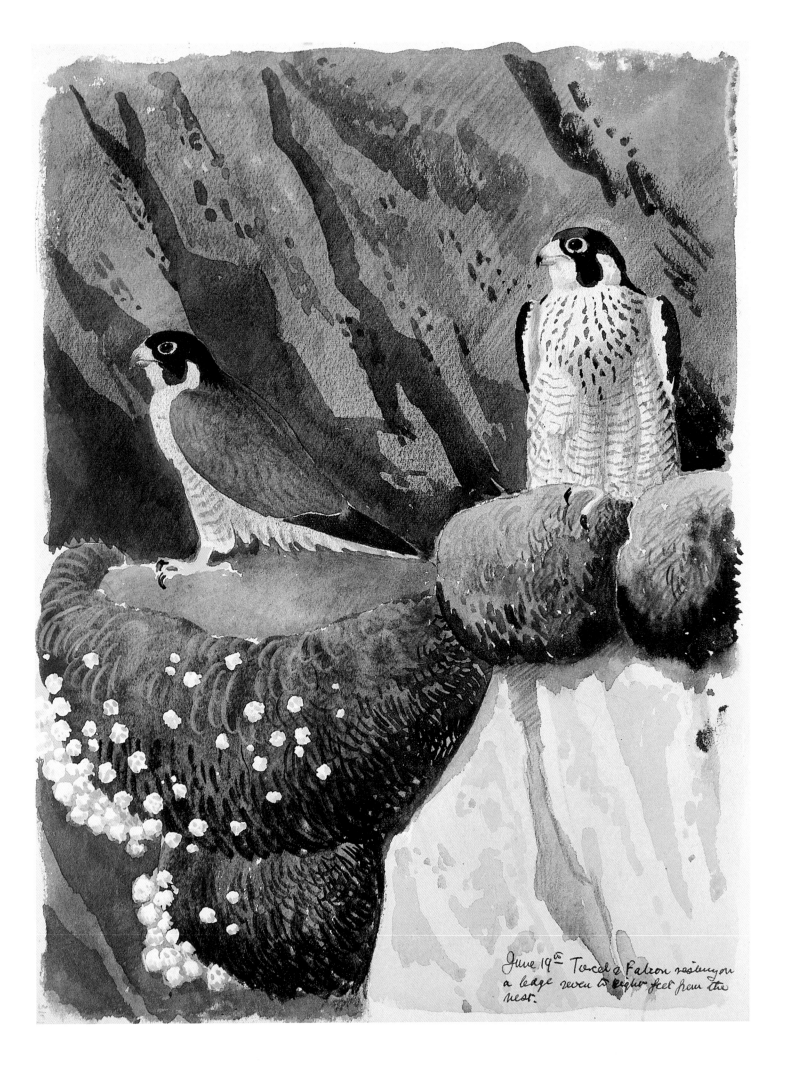

June 19th Torcel a Falcon resting on a ledge seven to eight feet from the nest.

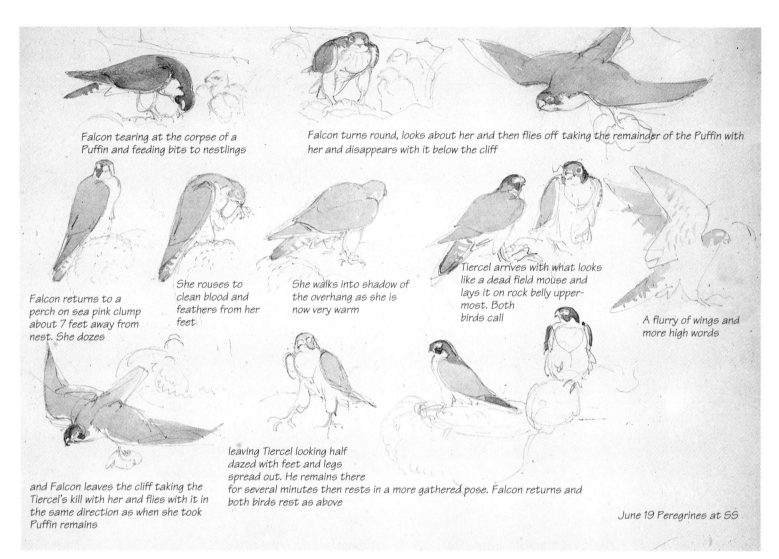

Falcon tearing at the corpse of a Puffin and feeding bits to nestlings

Falcon turns round, looks about her and then flies off taking the remainder of the Puffin with her and disappears with it below the cliff

Falcon returns to a perch on sea pink clump about 7 feet away from nest. She dozes

She rouses to clean blood and feathers from her feet

She walks into shadow of the overhang as she is now very warm

Tiercel arrives with what looks like a dead field mouse and lays it on rock belly uppermost. Both birds call

A flurry of wings and more high words

and Falcon leaves the cliff taking the Tiercel's kill with her and flies with it in the same direction as when she took Puffin remains

leaving Tiercel looking half dazed with feet and legs spread out. He remains there for several minutes then rests in a more gathered pose. Falcon returns and both birds rest as above

June 19 Peregrines at SS

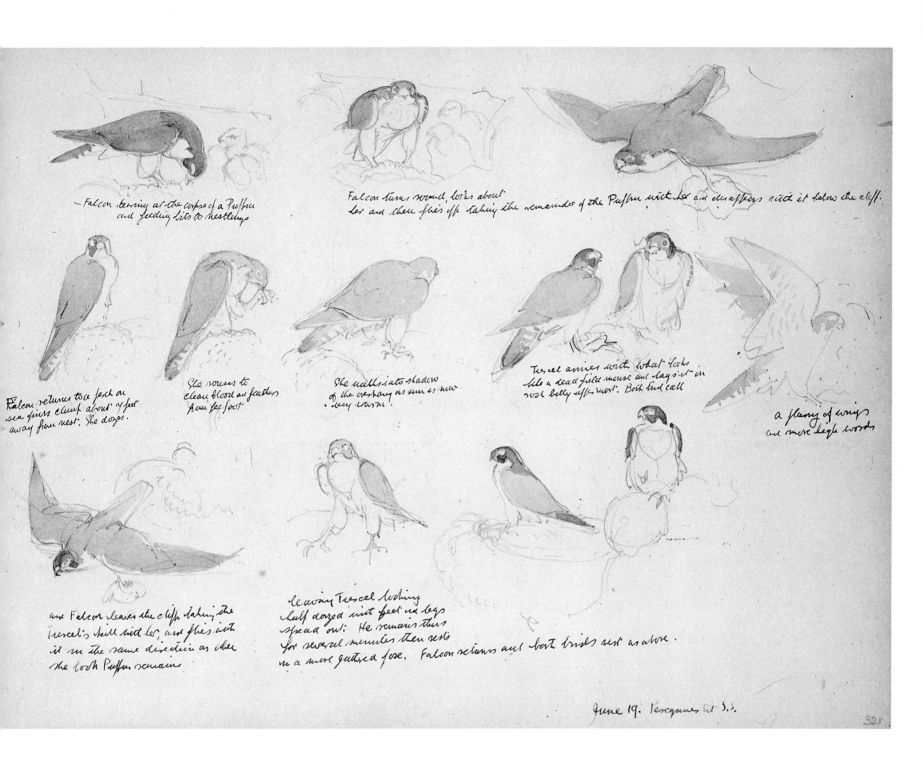

—Falcon tearing at the corpse of a Puffin
and feeding bits to nestlings

Falcon turns round, looks about
her and then flies off taking the remainder of the Puffin with her and disappears with it below the cliff.

Falcon returns to a perch on
sea pinks clump about 4 feet
away from nest. She dozes.

She rouses to
clean blood and feathers
from her foot

She walks into shadow
of the overhang as sun is now
very warm.

Tiercel arrives with what looks
like a dead field mouse and lays it in
rock belly uppermost. Both land call

a flurry of wings
and more high words

are Falcon leaves the cliff taking the
Tiercel's kill with her, and flies with
it in the same direction as where
she took Puffin remains

leaving Tiercel looking
half dozed with feet and legs
spread out. He remains thus
for several minutes then rests
in a more gathered pose. Falcon returns and both birds rest as above.

June 19. Peregrines at S.S.

325

31

JUNE 30th

By early afternoon I was on the South Stack cliffs again, and a quick look through the glasses showed the nestlings squatting in the nest. No parents were present. I was about to set up the telescope when I heard the high 'keck! keck! keck!' of a Peregrine and caught a glimpse of a swiftly flying brownish bird passing the lighthouse rock. It circled round, still calling, and as it presented a side view I saw that it was carrying something. Round it came again and then, passing low under my cliff, swooped up and landed on the tip of the nest and began to tear at its burden which proved to be a Puffin.

The eyesses were now on their feet. How they had grown since my last visit! Now their heads touched the rocky overhang above the nest and, as the falcon fed them she did not need to stoop. The larger of the eyesses was the first to be fed; it was also the more advanced in its fledging for, whereas the smaller eyess still bore wide patches of dull white down through which lines of dark feathers showed, the larger had patches of feathers with lines of down remaining at the edges of mantle, scapulars and tail coverts. Both had much down on their thighs, this creating a most amusing front view, especially in the larger eyess which looked as if it were wearing a striped cravat and waistcoat, billowing white pantaloons, and a slate-grey cloak lined with rather moth-eaten ermine.

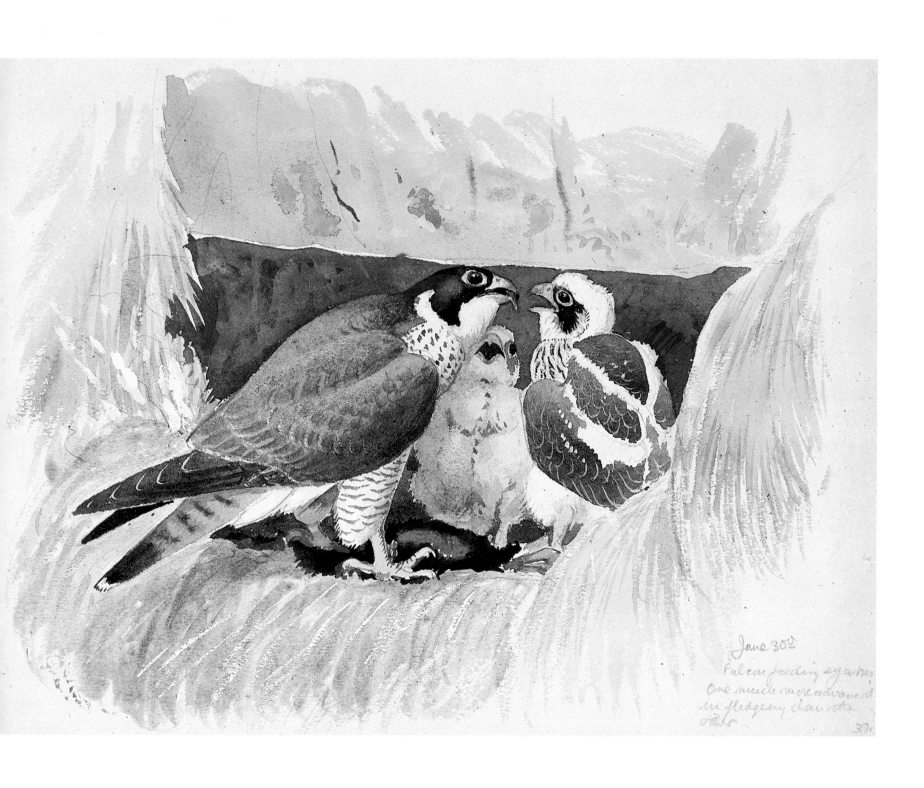

June 30th
Falcon feeding eyasses.
One much more advanced
in fledging than the
other.

37.

When the larger eyess was satisfied the smaller one was fed, and while the falcon was thus occupied the large eyess wobbled about the nest and, on one occasion, passed between the cliff wall and the falcon, jostling her and causing her to shoot out a wing to preserve her balance. Both eyesses now satisfied, the falcon, one foot still gripping the remains of her prey, called repeatedly as if summoning the tiercel, but he did not appear. Then for a time all was quiet but, presently, the larger eyess moved to the falcon and nibbled her chest. She eyed her offspring for a few seconds, then tore more fragments from the orange-legged remains and again fed her big child until it was satisfied. After another period of rest the falcon rose on her feet and began to call, then turned round, gripped the Puffin remains and flew with it round the cliff. A minute later she was back and made her perch on a clump of thrift near the nest. Here she called again but no tiercel answered. She moved on to the crest of the round thrift cushion and, stooping, wiped her bill first on one side then on the other. She then returned to the edge, perched and continued with her toilet, paying much attention to her feet. She dozed, lifting one foot, which sometimes dropped and rested on the rock, still clenched.

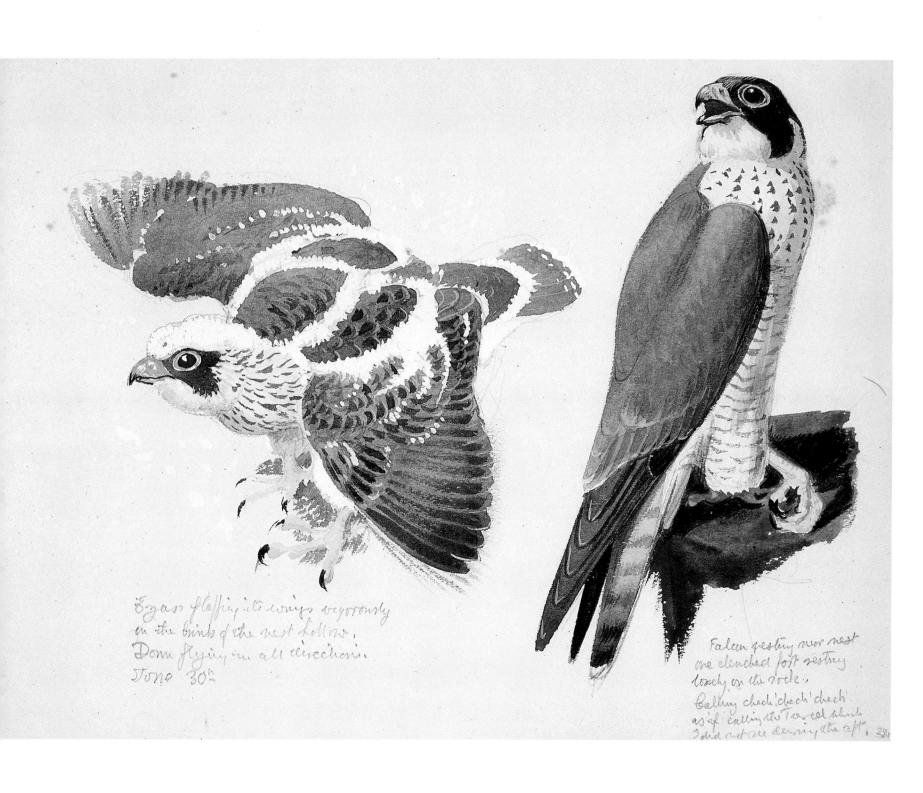

Eyass flapping its wings vigorously
on the brink of the nest hollow.
Down flying in all direction.
June 30th

Falcon resting near nest
one clenched fost resting
loosely on the rock.
Calling check check check
as if calling the Tiercel which
I did not see during the aft. 33

The eyesses moved restlessly about the nest and the bigger one, walking awkwardly to the edge, flapped its wings vigorously, sending clouds of down floating about the nest and the immediate surroundings. As it scrambled back the smaller eyess raised itself and nibbled the chest of its big sister (for I think the eyesses were small tiercel and large falcon). She looked down at him curiously then waddled to a corner of the nest and squatted with her head to the rock. The parent bird roused again and began to call. She flew over the sea in a wide arc, calling all the time, then returned to the cliff. Several times she made these short, questing, noisy journeys but no tiercel came and at last she settled on her cushion of thrift and slept with one foot up. I came away wondering what had happened to the tiercel. (On my last visit it appeared that he was rather henpecked.)

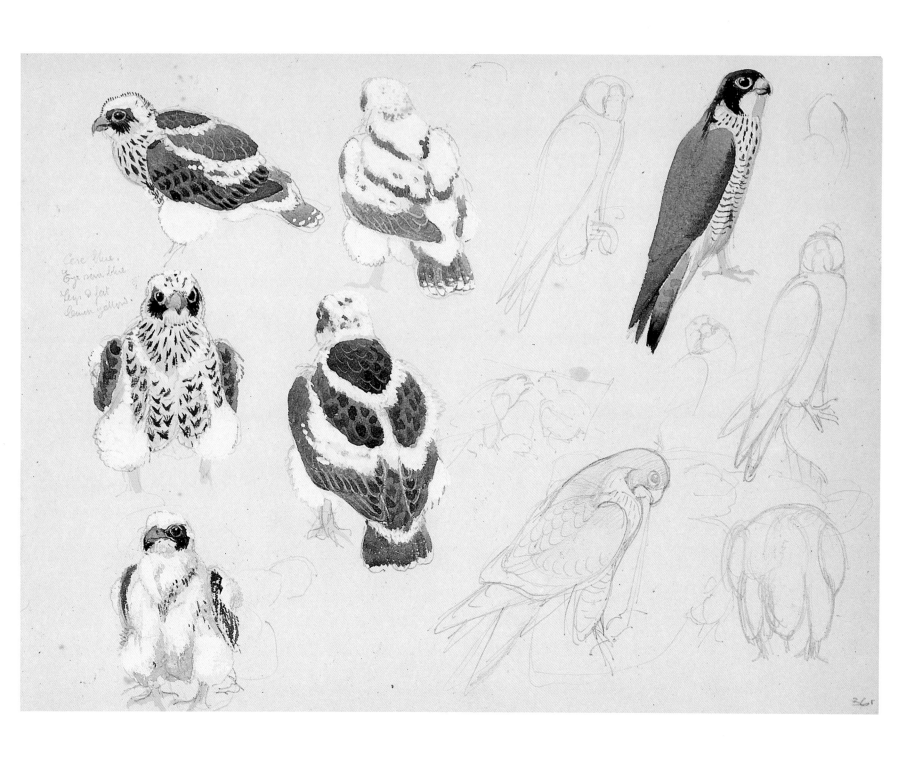

Cere blue.
Eye deep blue
Legs & feet
lemon yellow.

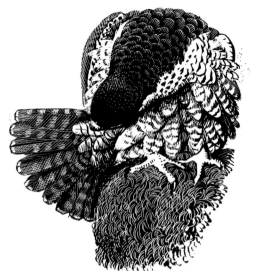

JULY 6th

Feeling that, as the eyesses were developing so rapidly, I ought to keep an eye on the Peregrine's nest, W. and I made an early start for South Stack. A strong wind was blowing into the cliff when we arrived but our usual look-out was fairly sheltered. A hurried glance through the glasses revealed the eyesses resting on a shelf of thrift six inches below the nest. Their heads were hidden behind the thrift but it was obvious they were well fledged. Above the cries of the guillemots came the quick call of a Peregrine 'Keck! Keck! Keck!' and soon the falcon was seen circling over the water. With a grand swoop she zoomed up the cliff face and came to rest near the nest, still calling. While I was watching the falcon W. saw the tiercel coming in from over the sea whereupon the falcon left her perch and flew up, again calling. The tiercel came to the cliff and alighted. The falcon then disappeared but soon returned carrying prey in her foot. She brought it to the shelf on which the youngsters rested but they were only mildly interested so the falcon took the food away from them and flew off closely followed by the tiercel. So closely did he follow that I thought he was about to take the falcon's prey; but no, she flew away from him, her burden trailing backwards from the speed of her flight. Presently she returned and alighted on a comfortable cushion of thrift where she first regarded her feet for several seconds, then fluffed out her feathers, shook them and preened, stretching her head back and tipping her tail to reach her under tail coverts, in which position it seemed impossible that she could ever again become the dignified bird of her quieter moments. But soon feathers were all in their place once more and she settled down to doze, head sunk into chest, white eyelids closing the dark eyes for a few seconds but never longer than that.

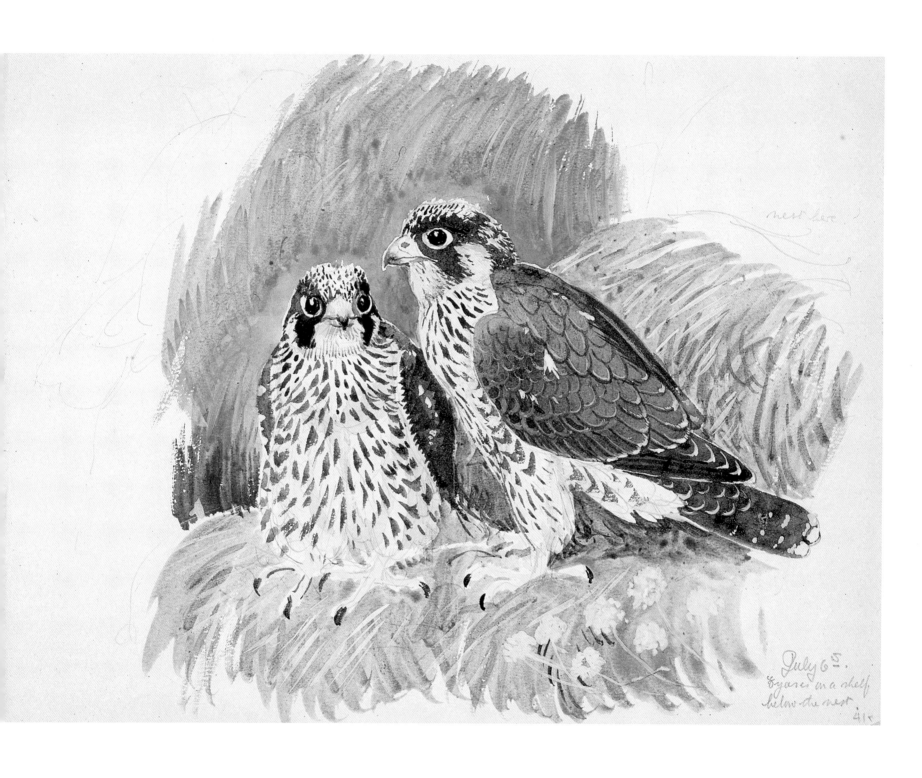

July 6ᵗʰ.
Eyases on a shelf
below the nest.

41

From overhead came a deep croak 'Quock! Quock!' The falcon gazed upwards and at once took off, circling up to give battle to three Ravens. She came up with them as they were disappearing over the top of the headland behind us and we saw only her first attack which was avoided by the Ravens. Then all the flying birds disappeared over the skyline and soon the falcon returned to her perch.

The eyesses, meanwhile, scrambled up into the nest proper and there indulged in wing flapping and again puffs of down were sent in all directions; only little tufts of white are now left on the bigger eyess, the brown-edged feathers of wings, back and tail coverts, and the dark-tipped buff feathers of chest, breast, and thighs being almost free of down. The smaller eyess had a few more tufts of white about him but there was little difference in the feather development of the two. It seems that the last down to disappear will be that on the crown for both eyesses are still very hoary-headed They scrambled about their nest, then seeming to prefer the lower position scrambled down to the shelf of thrift, and there squatted with heads to the cliff, pale-tipped tails sticking outwards, and went to sleep.

Thrift bloomed no longer round the nest; only the pale buff faded flower heads remained. A few white campions still flowered near the eyesses but all their immediate surroundings were streaked white in spite of their cleanly habits. All was quiet by the nest when we left, falcon and eyesses dozing, but the wind was increasing in strength and we were not sorry to leave the blusterous cliff edge.

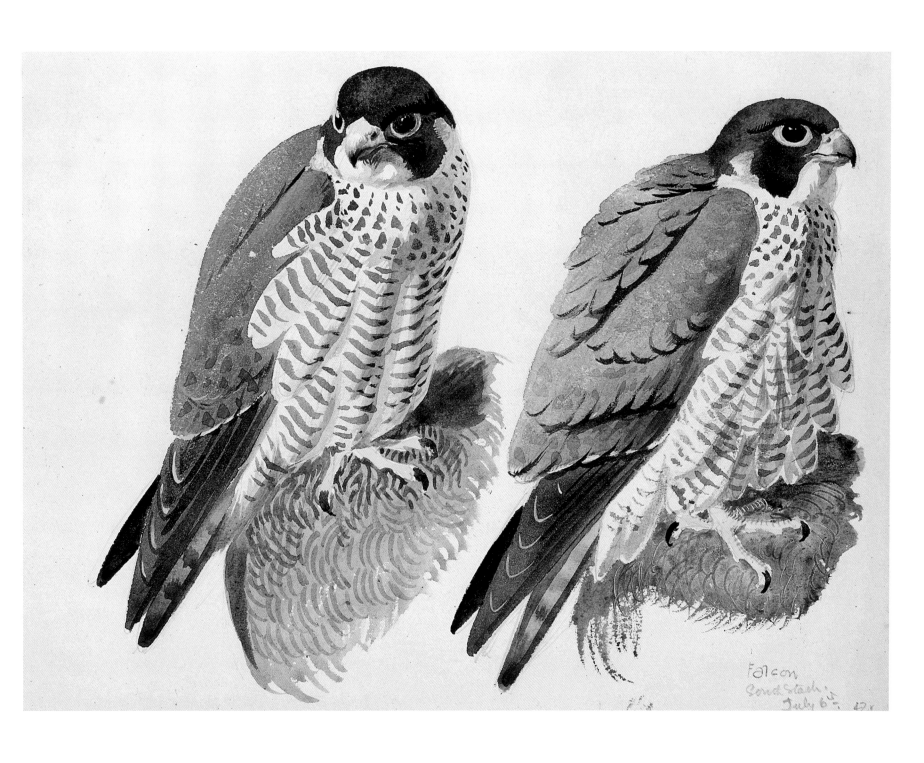

Falcon
Scardstach ?
July 6th 12 r

41

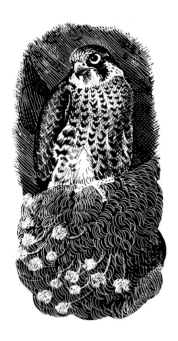

JULY 12th

By ten o'clock this morning I was climbing the hill to the South Stack again and hoping that I was not too late to see something more of the young Peregrines. The headland was a patchwork of brilliant heather and pale rock and as I walked down the rough track I chanced to look up to the top of the cliff, and there, on the pale rocks, their breasts golden in the morning sun, perched the falcon and one of the eyesses. The falcon began to call and, as I raised the glasses, the eyess took wing and sailed down the rocks and out from the cliff and was lost to view. The falcon also flew, still calling. Reaching my watching place I spied on the nest and saw one eyess sitting there, its back towards me but with its head turned so that it watched me Beside it was a jumbled shape of feathers and bones and, seeing what seemed to be tail feathers of a young Peregrine in this jumble the thought occurred to me that perhaps this eyess was the young falcon I had seen perching on the rocks above, and the feathers at its feet were all that remained of its young brother. But I soon dismissed this idea for close scrutiny with the telescope showed me that this eyess had not yet attained power of wing, and that it had yet to make its initial flutter from the nest. The falcon came sailing over the water calling hoarsely and soon, with an upward sweep, made her perch on a cushion of thrift. For a time she continued to call, then quietened. Then the tiercel was heard calling over the sea and soon he came into view with something dangling in his foot. He circled round but did not alight at the nest. The falcon watched him from her perch, following his flight with her bright, dark eyes until he swooped to his perch on a clump of flowering hawkbit which grew from the sheer face of the cliff thirty yards from the nest. He could not have chosen a more effective perch wherewith to set off his beauty. There he stayed most of the morning, his white chest gleaming against the cliff.

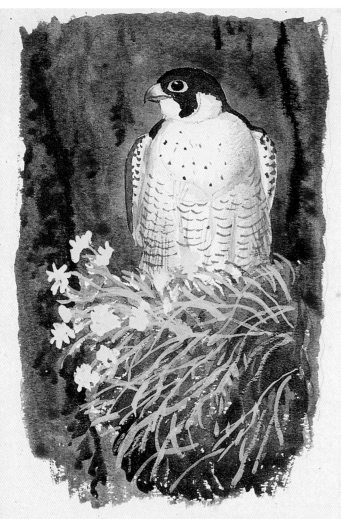

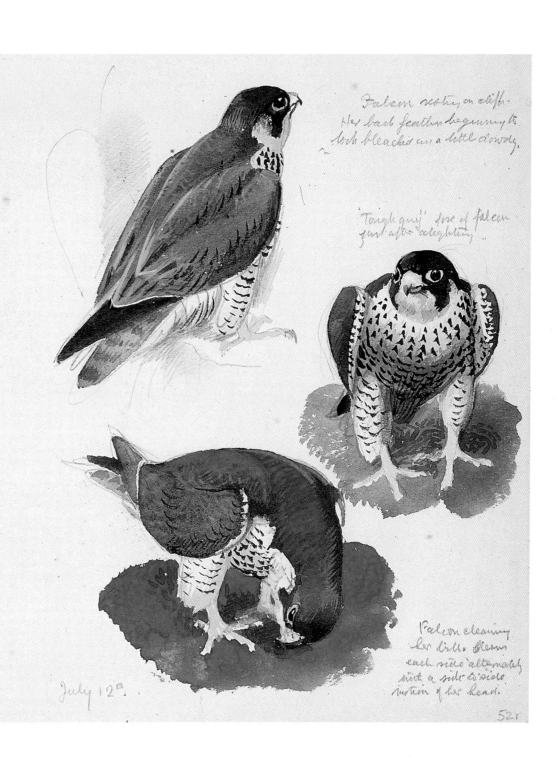

Tiercel perched on a clump of
rockbit growing from the
sheer face of the cliff. He
rested here for at least two hours
during the morning of July 12th.

Falcon resting on cliff.
Her back feathers beginning to
look bleached and a little dowdy.

"Tough guy" pose of falcon
just after alighting.

Falcon cleaning
her bill. Cleans
each side alternately
with a side to side
motion of her head.

July 12th

52r

The falcon made several flights returning to different perches near the nest. She is looking a little dowdy and worn, especially about her back which looks brown and ready for a change of coat. On one of her returns she alighted on a cushion of thrift and at once began to clean her bill. I could only surmise what she had been up to, but remembered that several minutes before she landed there had been a great clamouring of gulls farther along the cliffs, in which every gull of the neighbourhood seemed to be in the air.

Happening to look up to the rocks of the headland above the cliff I saw a grey fluttering bird among the patches of rock and heather. It was the eyess falcon. It clambered here and there, moving awkwardly on its pale yellow feet, balancing with a sudden out-thrust of a wing, over bumps and clumps until it reached a flat patch of heather which was a solid mass of bloom. On this patch the eyess stood and opening its wings beat them rapidly for a minute. It was a most beautiful sight. Soon she moved from the patch, wings often being used to help her over the bumpy ground, and finally squatted behind a heather clump over the top of which only her head was visible. At the nest the smaller eyess was up on his feet and tearing away at the remains in the hollow. I could see that some red meat was still on the bones and this he tore greedily, swallowing fragments. When he had fed he scrambled over the edge of the nest and down to the shelf of thrift, where he came to rest with his striped breast facing towards me.

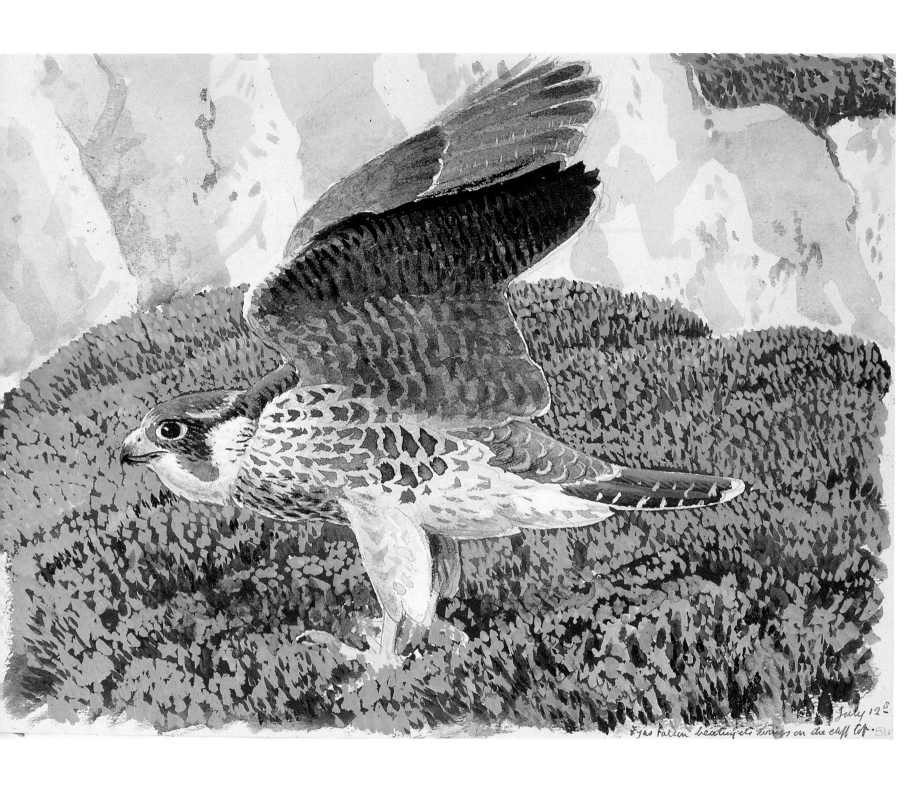

July 12th

Eyas Falcon beating its wings on the cliff top. 51

By this time both falcon and tiercel had left the cliff and did not return during the remainder of my stay. Sleeping eyesses, overcast sky, a rising wind and drops of rain induced me to leave the lovely heathery headland after a watch of four hours.

Today I had been struck by the blue-grey appearance of the eyesses, especially of the young falcon, which appeared much bluer than the adult falcon, while the young tiercel was a dark slate-grey on his back with paler edges to his feathers. Why many bird books insist on the brownness of young Peregrines I do not know.

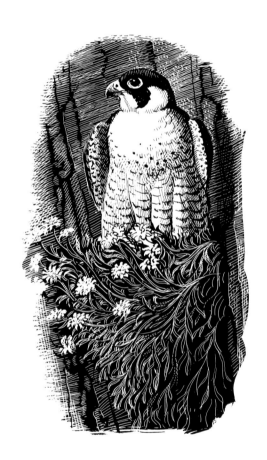

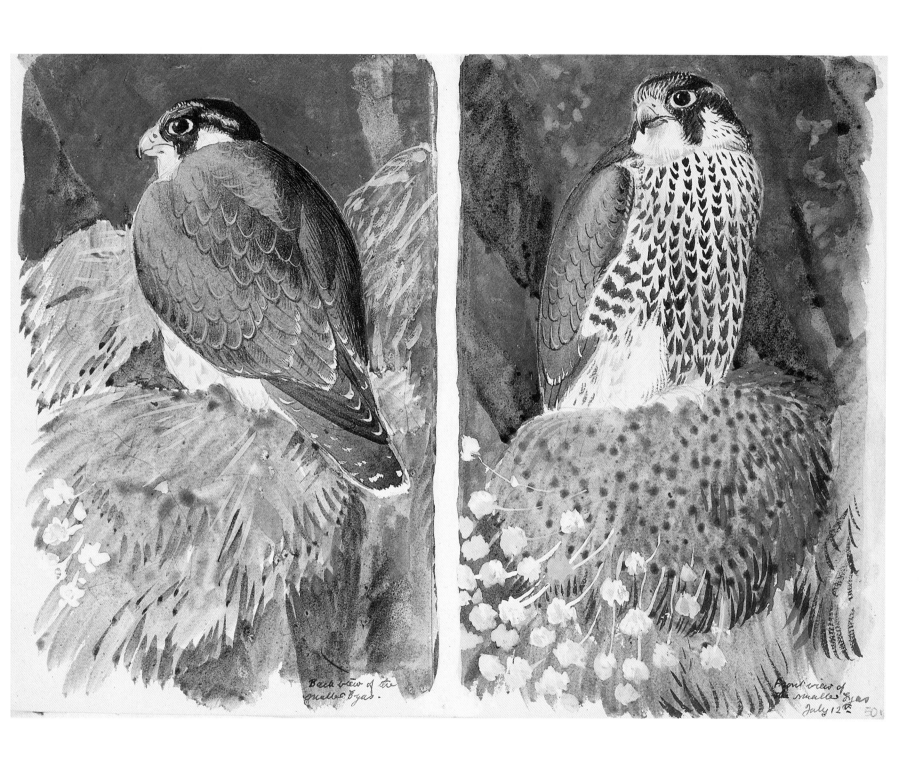

Back view of the
smaller Eyas.

Front view of
the smaller Eyas
July 12th
50

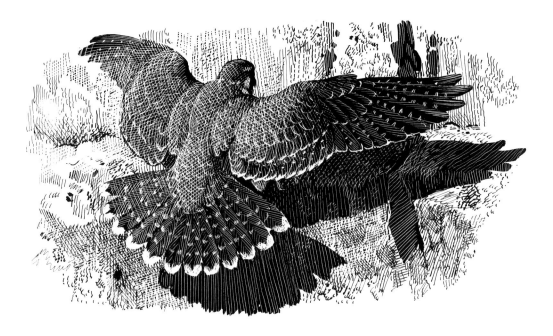

JULY 14th

The South Stack Peregrines are an irresistible attraction. At two-thirty p.m. we were on the cliffs again, scrutinising the rocky buttresses of the face, and the wild garden of the cliff tops, where heather and hawkbit and stonecrop bloomed among the rocks, as colourful as a Persian manuscript. For several minutes no Peregrines were to be seen, and, as expected, the nest was empty, but soon a dark sharp-winged shape was glimpsed as it showed against the blue water and we saw that it was one of the eyesses. The pale tips of its tail feathers were very conspicuous as it opened them to swoop up the cliff. The eyess attempted to alight on a ledge but, misjudging its landing, heeled over and dropped down and out from the cliff to make another swoop up, this time to alight on a little ledge where a patch of heather was in bloom. What perfection of plumage was his! (for it was the male eyess). From cream-tipped tail to dark crown not a feather was out of place. His finely modelled back shone in the sun, and his dark watchful eyes gleamed as he turned his head to regard us.

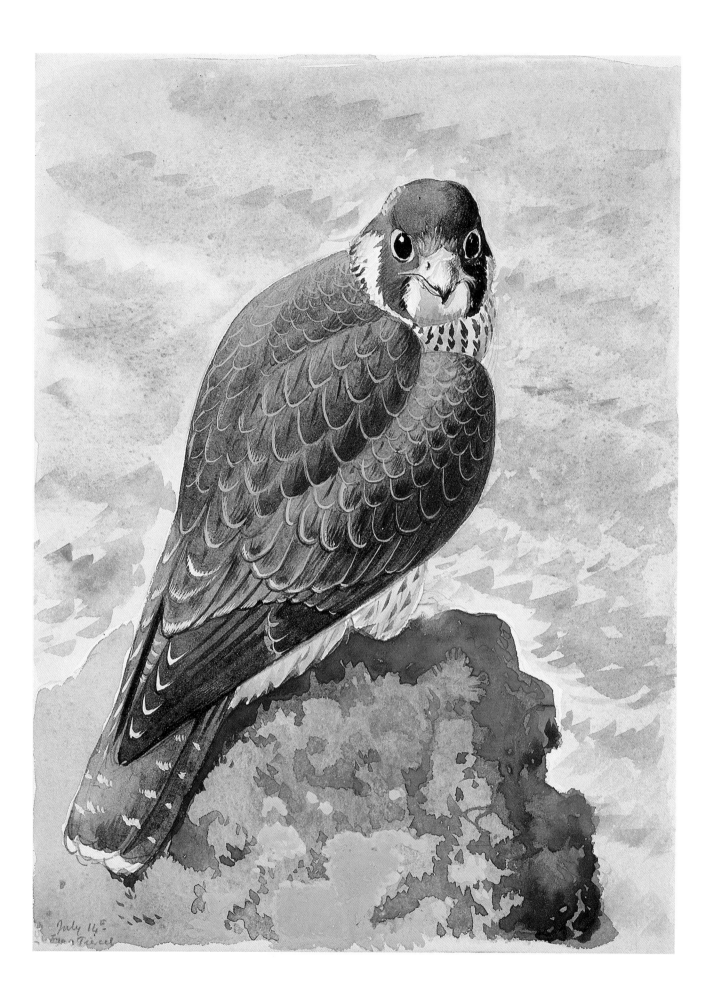

July 14th
Frank Renoul

Out at sea a Peregrine called and the big old falcon came cutting along on stiff wings, almost into the very face of the cliff, but at the last moment she swooped up and made her perch near the nest site. Her cries continued and it seemed as if she were warning the eyess of our presence for he left his perch and flew under our cliff. I moved some yards to the left and, looking over and down, saw the eyess perched on an upjutting rock, whose lichened shape had for its background the blue water below. The eyess looked perfect in this setting, and rather feverish mental notes were made and some scribbles in the sketchbook. Still another Peregrine came in from the sea, and this time it was the young female which arrived. She is considerably bigger, and of a paler colour generally than her brother, indeed, when she opened her wings in braking to land she looked a pale grey bird against the cliff. At rest she proved to have paler edgings to her feathers, and to have more pale streaks about the crown and forehead than had the small eyess. She alighted on a white-streaked grassy ledge where a few bones and flight feathers lay, and which was obviously the scene of a previous meal. The old falcon called again and the eyess falcon answered with her high falsetto. The eyess was feeling the heat of the afternoon sun for with drooping wings and open bill she panted.

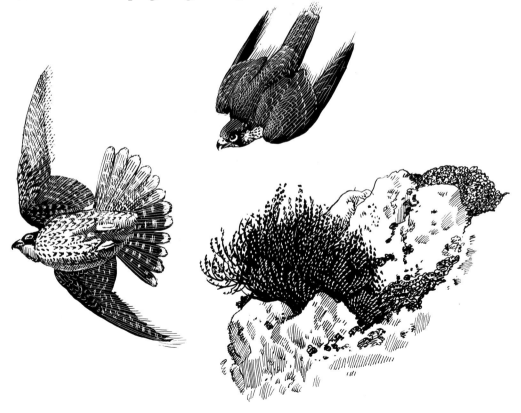

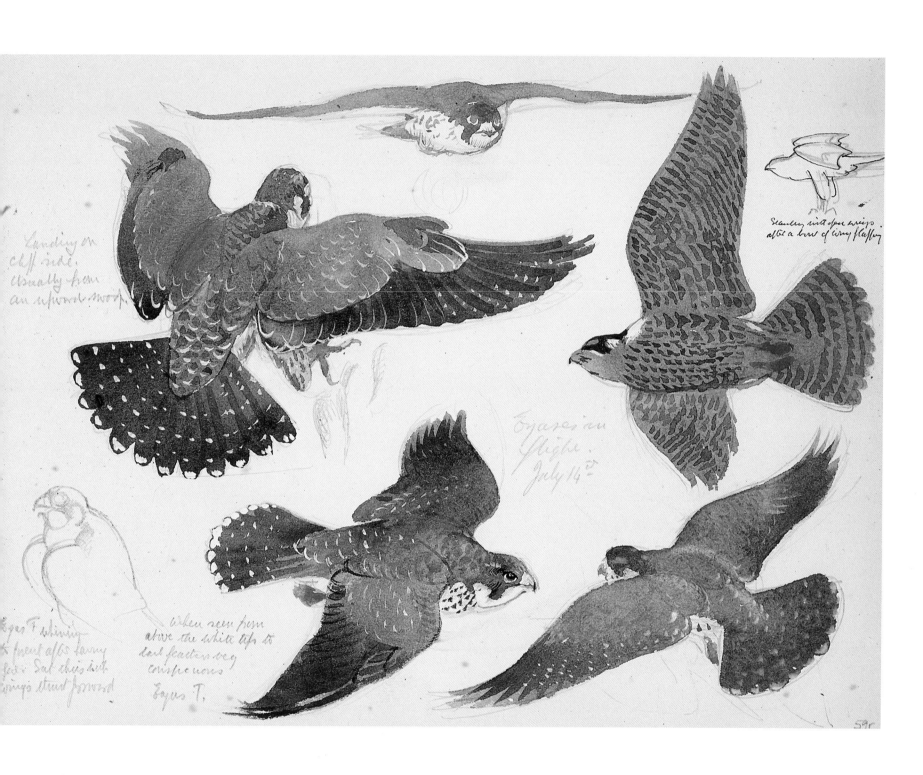

Landing on
cliff side.
Usually from
an upward swoop.

Standing with open wings
after a burst of wing flapping

Eyases in
flight.
July 14th

When seen from
above the white tips to
tail feathers very
conspicuous
Eyas T.

Eyas T whirling
to front after having
faced. Did this with
wings thrust forward

The eyesses flew restlessly from rocky ledge to grassy shelf, sometimes scrambling about the heather and rock of the cliff top, with a queer hopping run as if they were suffering severely from corns. Walking is one of the few actions in which a Peregrine is not dignified. It was while they were scrambling thus that the young tiercel exercised his wings. Head to wind, he perched on a flat compact cushion of heather and beat them vigorously for a minute, then stood quite still with wings open as if delighting in the feel of the breeze on them. He stood poised, body held parallel with the ground and wings and tail also held in the same plane. While it lasted it was breath-taking in its beauty. Often the eyesses called, as did the old falcon, which made several flights from her ledge calling all the time. Later she moved into the shadow of an overhanging ledge and settled there.

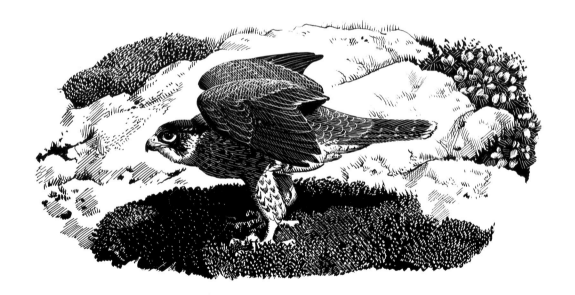

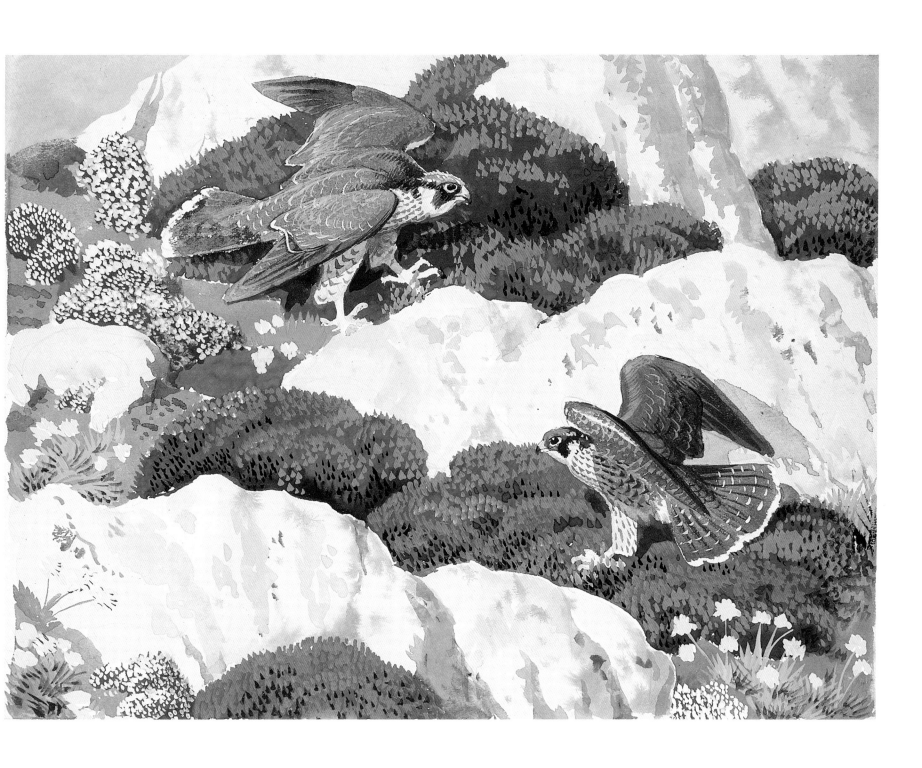

All was quiet for a time except for the noise of the Guillemot colony, from which came an ever varying discord of noises. Listening to this sound for any length of time one became aware of a sort of underlying melodious chorus, almost like the distant sound of children singing in school, a kind of dreamy background to the more high and discordant noises. Gulls too added their high calls and staccato utterances and, on their own particular rocks, were busy watching or feeding their well-fledged grey young, which looked like fragments of the grey rocks themselves. It was while we were watching the Herring Gulls that we again saw the eyess tiercel flying about the Herring Gulls' own special domain, and, not content with flying round it, he eventually alighted on the rocky crest of it only a few feet away from a pair of young gulls. Down came the old gulls, in swoop after swoop, and at each swoop the tiercel ducked. He endured this for perhaps a minute, then took wing and slipping away from the continued stoops of the gulls, disappeared round a shoulder of cliff. He came into sight again, some moments after, above the cliff top where we now saw the eyess falcon perched on a rock. The young tiercel came down and knocked her off her perch, then swooping up came down on her again, causing her to duck quickly. He repeatedly swooped at her, and at last, she took wing, but in the air she was not free of his attentions for again and again he swooped. She was very adroit in slipping away from him and together they gave a very pretty exhibition of flying. They returned to the cliff top and alighted on a flat rock near the top. At once the young tiercel approached his sister, wings drooped, shoulders hunched, and neck low, and whined as if asking her for food. From her superior height she looked down on him, her big dark eyes regarding him with almost a puzzled look. The next moment he was fondling her chest and nibbling her bill with his; she nibbled his in return, but he got no satisfaction from that and began to whine again. He was obviously hungry.

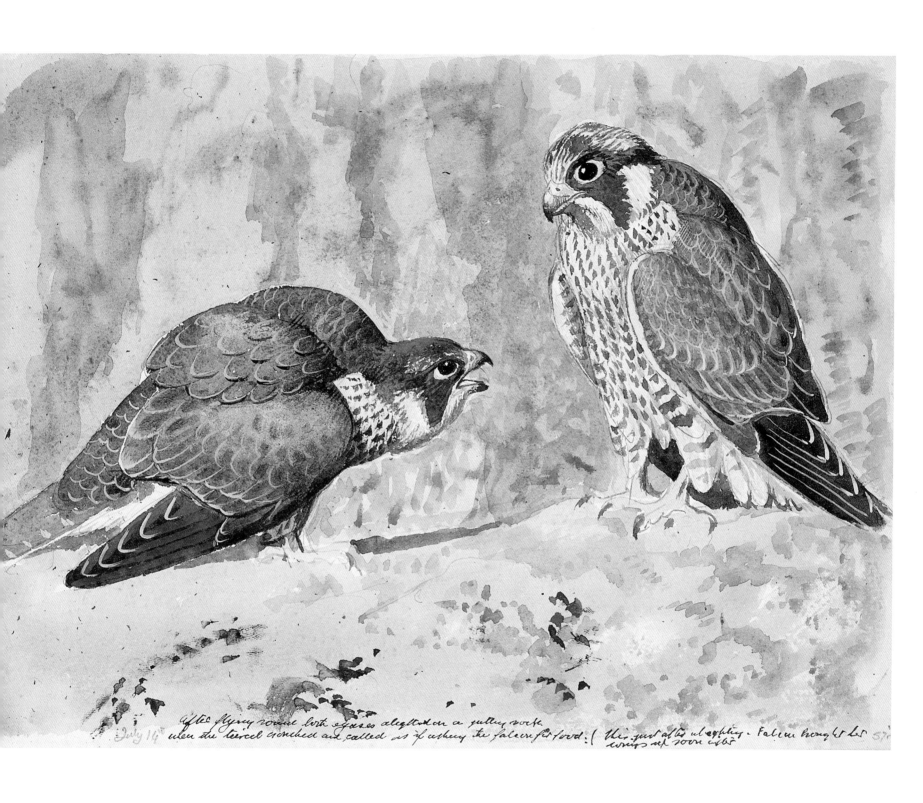

July 14th. After flying round both *cases alighted on a jutting rock.* when the tiercel crouched and called as if asking the falcon for food. (this just after slaughter. Falcon brought her wings up soon after

Presently we heard the falcon calling from her retreat down the cliff face and, a moment afterwards, she sailed out from the cliff and swiftly beat out over the water. She turned south and flew down the rocky coast and was soon a black speck in the blue sky with the whole of Lleyn to Bardsey stretched on the horizon below her. She disappeared round the headland of Penrhyn Mawr.

Perhaps ten minutes elapsed before we heard her calls again and saw her coming in to the cliff with something dangling in her foot. She alighted near the nest, one foot still gripping her prey, and looked up the cliff as if searching for the eyesses. Then she began to pluck the white breast of her prey. Vigorously she worked, her fine head and neck stooped, the inner claws of each foot holding her kill. Soon a mound of white feathers was piled about her and, having exposed the breast of her victim, she began to tear at it in earnest. She fed herself, tearing and swallowing, tearing and swallowing, hungrily. It was impossible to identify the prey with certainty for it was headless. The plumage was black above and white below and the feet were black. It seemed smaller than an adult Razorbill.

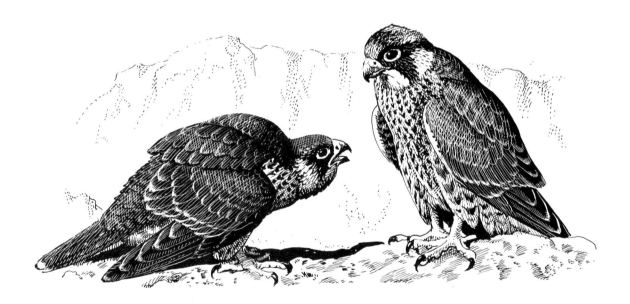

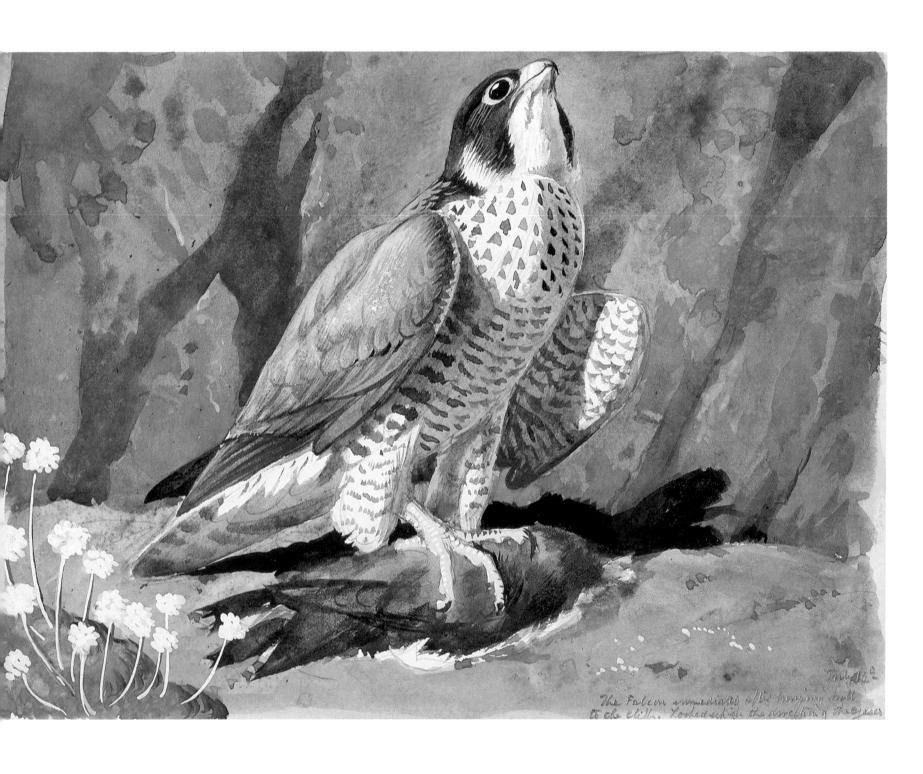

The Falcon immediately after having shot
to the cliff. Looked upon the wretch of the goose

Her hunger satisfied she gripped the prey in one foot and took wing, calling as she flew. She swung round and beat up the cliff still calling but failed to see the eyesses which were still together on the rock near the top. Several times the falcon flew round, then went in direct flight to the eyesses and landed with the prey a yard from them. Both eyesses rushed at her, seeming to overwhelm her with beating wings. The prey was knocked into a clump of heather and, in a few moments, the little tiercel emerged from the heather and the hurly-burly with the prey, over which he spread his wings and called whiningly. The old bird stood on the rock a yard away calling continuously, as if admonishing her unruly children. The eyess falcon stood calmly by and watched her brother who presently ceased his whining and began to tear at the carcass. He fed until he was satisfied, then his big sister walked in and without fuss began to tear and swallow. Presently we saw that she was tugging at a leg and soon she had pulled it from the carcass and was attempting to swallow it; she gulped and gulped at the black leg sticking out of her bill. Slowly it disappeared and, as it did so, it made a bulge at the back of the eyess's neck. Slowly the bulge disappeared and the eyess was still for a few moments before resuming her tearing. The little tiercel sat on his tail, crop bulging, wings thrust forward, as if he had fed too well. The old falcon flew away down the cliff and came to rest on a bracket of thrift growing from the sheer cliff face and there went to sleep. When the eyess had finished her meal and was resting beside her brother, both birds very drowsy with food and heat, we came away feeling glad that the Peregrines had been able to rear their young successfully and unmolested.

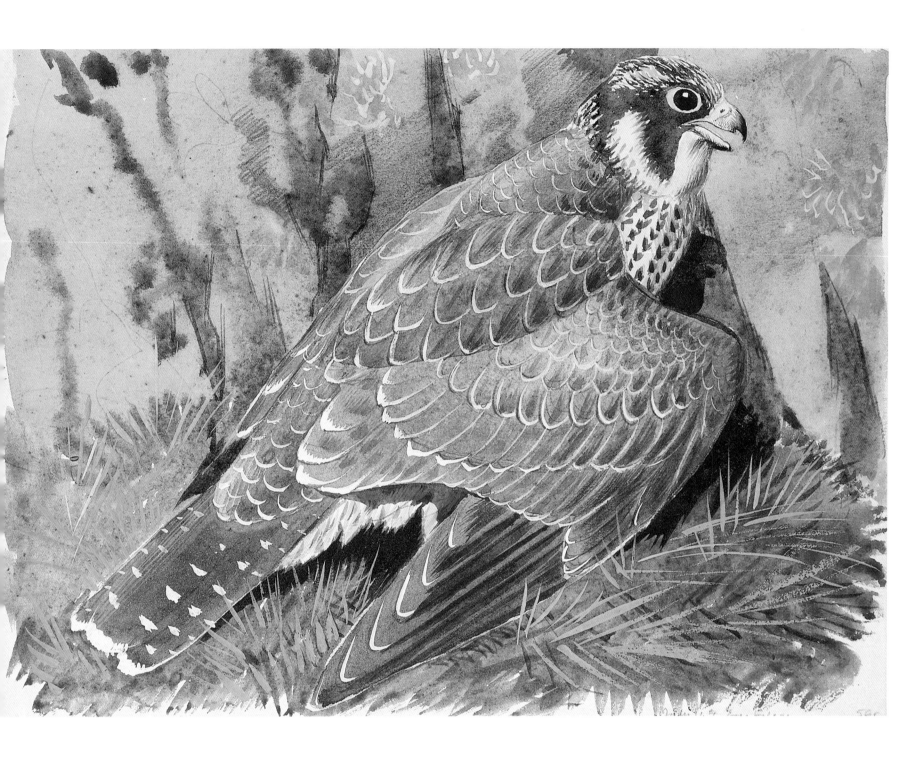

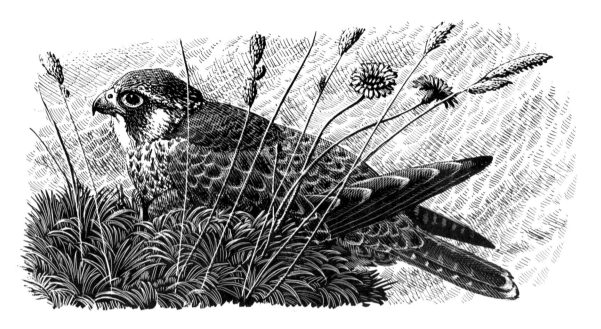

JULY 20th

What a morning! I awoke to the sound of Curlew and Oystercatchers piping by the river, and on rising and going to the studio window found birds everywhere. On the garden wall was a line of Starlings and sparrows, and beyond, at the bend of the river, there was a fine group of Lapwings, Curlew, Gulls and Oystercatchers. Two herons were flapping lazily from the direction of Bodorgan, over the sands to Cob Lake, their background the blue cloud-capped Rivals. With such a start to the day it seemed but natural that mid-morning should find me at the South Stack cliffs again. Reaching a point mid-way down the headland brought me in view of the falcon's cliff. All was quiet. No Peregrines were to be seen or heard. I continued down the slope, almost to the end of the jutting cliff. Eleven feet from the edge I was brought to a sudden halt, for I had caught a glimpse of a barred under-wing and tail disappearing from a shelf just over the edge. I was about to step forward when on this same cliff, which was partly screened by tall grasses, I saw the Eyess Falcon resting.

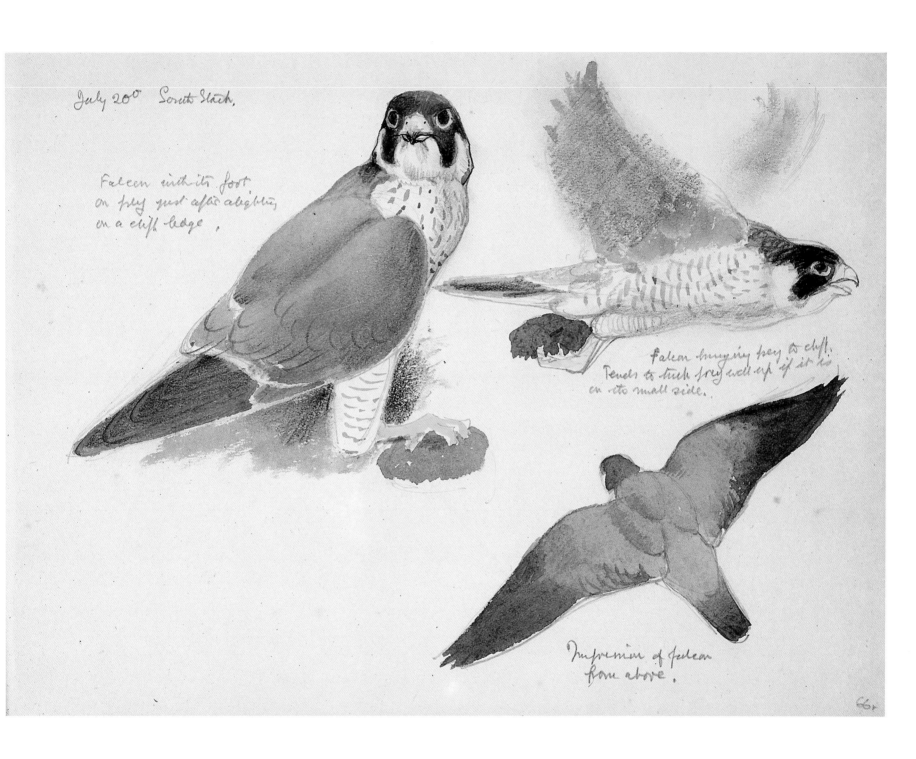

July 20th South Stack,

Falcon with its foot
on prey just after alighting
on a cliff ledge .

Falcon bringing prey to cliff.
Tends to tuck prey well up if it is
on its small side.

Impression of falcon
from above .

61

Luckily, when she turned her head I was absolutely still, and she failed to recognise me as something living and turned her head away. I gloated on her beautiful shape and on my amazing luck in finding myself only eleven feet away from a wild falcon. She was a big bird with a fine head. She rested on her breast on the green shelf, her tail projecting and partly lowered over the edge; her wings were relaxed and rested on the turf. I watched for perhaps five minutes, during which I tried to memorise as much as I could. Then something happened; perhaps the oilskin, which I use as a groundsheet, moved in the breeze for she suddenly looked full at me, then literally threw herself from the cliff and swooped away. For a time I watched the two eyesses, and as they flew about the cliff tops and over the water their increased confidence and power of wing was apparent. They glided and swooped, soared and banked, tails now closed as they flew straight, now fully opened in a fan shape as they turned; their flight was beautiful to watch. They disappeared round the far shoulder of cliffs and I saw them no more. But soon after their departure the old falcon arrived, calling loudly as usual, and with something held in her foot. She made her perch on a cliff ledge and, still calling, looked about her, but the eyesses did not reappear. Later she took her prey away from the cliff and, returning without it, alighted on a bracket of sea-pink which jutted from a crack in the vertical rock face. There she rested during the remainder of my stay, her feathers blown out by the breeze, one foot tucked up, her head often stretched sideways to peer out from the cliff as if watching for her wandering children.

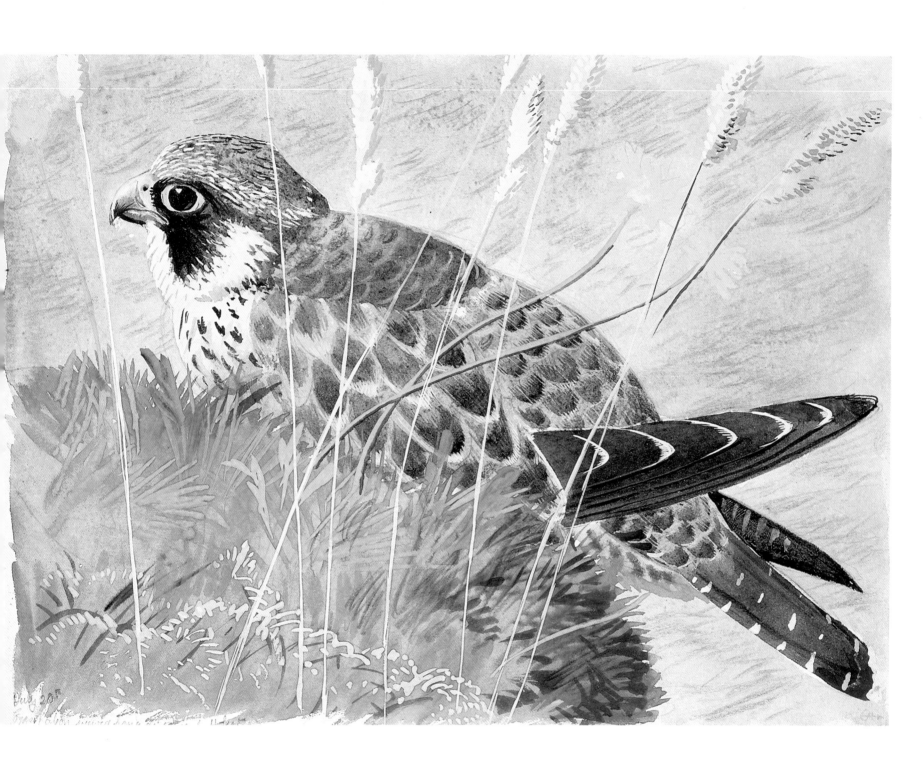

AUGUST 7th

Visiting relatives' desire to see the South Stack, and a much keener desire on my part to see something further of the falcons were sufficient reasons to send us heading in the direction of Holyhead. The sky was grey with a layer of high cloud which turned the mountains to blue silhouettes sharply outlined. All the way to Holyhead their fine shapes loomed over the Anglesey landscape, of fields and rocks and stone farmhouses, and when we reached South Stack cliffs visibility was so good that we could see the pale blue shape of the Irish Hills on the south-western horizon, and further north the Isle of Man. I searched the cliff face for a possible resting falcon but found none. I swung the glasses on to the cliff of the Guillemots and Razorbills, and though there were enough birds to form a thin chorus of calls, their numbers had greatly diminished, and many of the ledges which had been crowded on July 20th were now quite empty. However the vacating of the ledges by the majority had made it easier to examine individuals, and through the glasses I caught glimpses of young birds which I decided to study more closely later. My niece, who had borrowed the field-glasses a moment before was disgusted at the speed with which I deprived her of them when I caught sight of a dark shape swinging round the cliff below. The shape proved to be the eyess falcon. Now strong and confident of wing she turned and glided and finally came to rest on the great shoulder of rock where many Herring Gulls had nested, and whose grey, well-fledged young were still mewing and nuzzling their parents for food. There she rested on the rocky cornice unmolested by the gulls, during the whole period of our watching.

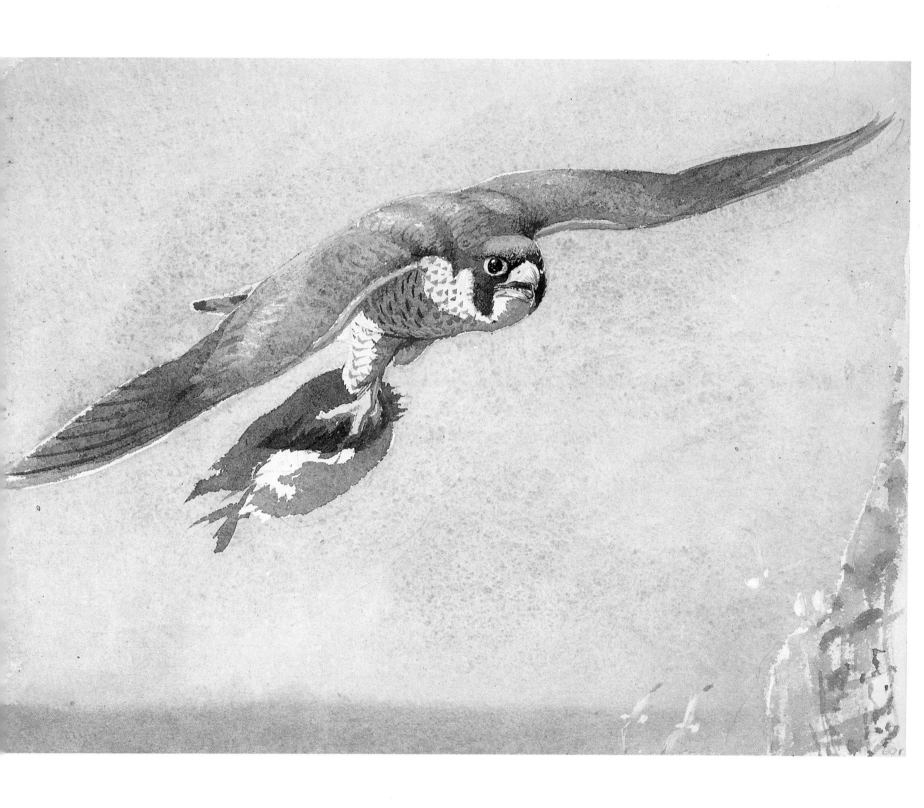

Chancing to look along the cliff I saw one of the Peregrines swing into view and approach rapidly. Suddenly it swooped at a Guillemot flying below it The Guillemot dropped like a stone, 'belly landing' with a splash, and dived away. A swift turn, a flicker of wings and a glide took the Peregrine out of sight round the cliff.

In the evening, as the sinking sun glowed below a cloud bank in the west, the mountains were strange and magnificent, strange because of the cloud formation which lay on some of their shoulders like an unrolled fleece. A part of the fleece moved slowly up Snowdon's flank, rolled over his shoulder and his peak, leaving it clear for a few moments.

In the gap between Elio and Snowdon a great cloud, like a pale yellow flame flared up, throwing the rounded contour of Elio into sharp relief. Chasms and precipices of the mountains were one moment in shadow, the next in bright sunlight, and unfamiliar contours were now revealed in a pageant of form and light indescribable by words. The little farms on the mountainsides gleamed and their windows flashed as they caught the light of the sinking sun. How insignificant the works of man appeared beneath the awe-inspiring magnificence of mountain and cloud!

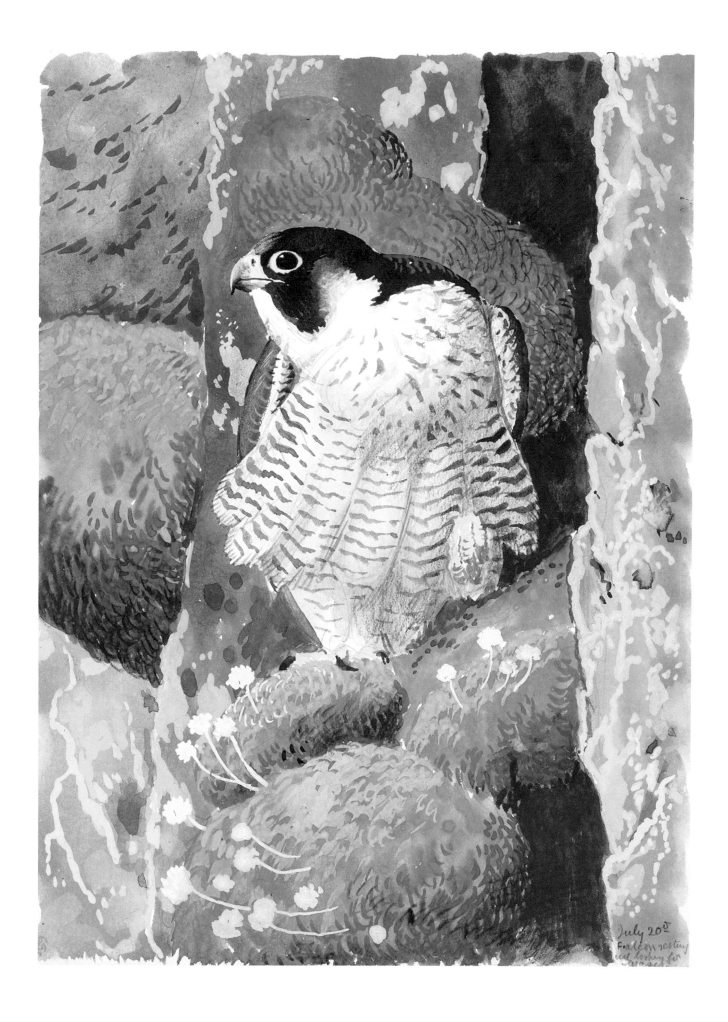

July 20th
Falcon resting
and looking for
prey

AUGUST 22nd.

This afternoon we, that is 'Holly' and Mrs. Holly (who are on a visit to us), Winifred and I, went to the South Stack as I wanted H. to see the Peregrines if possible. When we arrived on the cliffs a strange quietness pervaded everything; even the gulls were quiet. I looked towards the cliffs on which the Guillemots, Razorbills and Puffins had nested. All the ledges were bare, and the cliff-nesters, young and old, had departed, and with them had gone the chorus of sounds which had echoed about the cliffs all spring and summer. I scrutinised the ledges and the pinnacles for my Peregrines but could not find them and the thought occurred to me that the departure of Guillemots, Razorbills and Puffins meant that the chief food supply of the Peregrines had also disappeared so that now the falcons had no reason to linger in the vicinity. We saw no sign of them during our visit and we had to content ourselves with the solitary Shag which was standing by its well-grown young on the nest at the base of the cliff, and with the Herring Gulls still being pestered for food by their importunate grey youngsters which for their persistence received many a peck and buffet from their parents.

THE ANGLESEY
PEREGRINES

by

Derek Ratcliffe

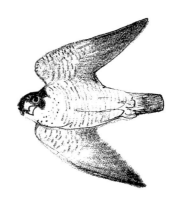

WHEN CHARLES TUNNICLIFFE'S *Shorelands Summer Diary* appeared, in 1952, I was a research student in Bangor, and eagerly bought a copy. I was delighted with his beautiful paintings and drawings, but especially of Peregrines with their eyasses, in their time-honoured nesting haunts at the South Stack on Anglesey. Only the previous year I had been to this fine headland to see its seabird colony. Although it was June and the Peregrines should have had young, I saw only a solitary female, which did not behave as though it had a nest. This did not strike me as particularly untoward at the time. The pairs that I knew inland in Caernarvonshire did not seem to be doing too well, either, but it was a time when egg collectors were still pretty active, and this provided a simple explanation.

Peregrines were then scattered along the rockier coasts of North Wales and through the rugged mountains of Snowdonia, their numbers being evidently limited by the territorial demands of each settled pair. About three or four miles between adjacent pairs was the usual closest distance where good cliffs were plentiful, but they were more widely spaced out or absent where suitable nesting rocks were few or missing. Edward Forrest, writing in his *Fauna of North Wales* in 1907, said that "the Anglesey cliffs accommodate perhaps five or six pairs" and, despite the legal harassment during World War II (in defence of military carrier pigeons), this was about the number known to local ornithologists by the early 1950s. A remarkable feature of Peregrine breeding populations, both in North Wales and many other parts of Britain, was their constancy. In some districts where good

records had been kept, numbers had shown only very minor ups and downs over periods of up to 50 years. Many nesting stations were occupied faithfully, without a break, for as long as anyone could remember. The one on the Great Orme's Head by Llandudno was known to falconers during the reign of Queen Elizabeth I.

Forrest remarked also on the persistence of Peregrines at certain well-known eyries which were harried relentlessly, year after year, for their eggs or young. George Bolam, in his *Wild Life in Wales* (1913), observed that at Peregrine eyries on the then heavily keepered grouse moors of Merioneth, one or both birds were often killed at the nest, but by the following year the survivors had re-mated or completely new pairs had appeared. Such was often the story in other districts, in Scotland, England and Ireland, too – of long-continued persecution, but Peregrine numbers holding up remarkably well in spite of it. This seemed to be an extraordinarily resilient species in the face of adversity but, clearly, enough young were being reared somewhere to make good losses in the breeding population. What we do not know is how far this persecution prevented the bird from expanding into other potential nesting areas or re-occupying long-deserted haunts.

In April 1951, I witnessed a strange event at a Peregrine eyrie in the Lake District. Returning to a nest that held three eggs a few days before, I watched the female eating one of her own eggs and found that one of the others had been broken earlier, evidently in the same way. Later that month I was back in Snowdonia and saw an inland eyrie in which an egg was later broken. In 1952, two ornithologists were watching an inaccessible nest near Conwy, when they saw the female Peregrine apparently eating its own eggs. These mishaps continued, and during the period 1951-56, out of 60 Peregrine eyries that I visited, in England, Wales and Scotland, no fewer than 14 contained one or more broken eggs. Typically, these nests failed, and sometimes their eggs were lost one by one.

By 1956 it was clear that something very peculiar was afoot, and I began to think that perhaps some of the earlier nest failures had not been caused by eggers after all. In 1960, a different problem arose. Homing pigeon fanciers in South Wales claimed that Peregrine predation on their cherished racers was increasing rapidly, and petitioned the government to remove legal protection from falcons, at least in some districts. The British Trust for Ornithology was asked to make a study of the distribution, numbers and food of Peregrines in Britain, and invited me to organise their enquiry. This was done by appealing for help from everyone with an interest in the bird, but especially the BTO Regional Representatives, who collated information locally. The outcome was quite unexpected.

The Peregrine Enquiry was spread over the two years 1961-62, but by the nesting season in 1961, it was clear that – contrary to what the pigeon fanciers had claimed – the species was in the middle of a headlong decline. The once large population (120 pairs) of southern England had all but disappeared, and the still greater numbers (135 pairs) in Wales were much reduced. Decline was marked in northern England, but in Scotland the picture was variable, with reduction in some districts, but little change in others. The "crash" continued through 1962 and into 1963, when the breeding population for the whole of Britain was estimated as only 44% of the 820 pairs reckoned to be the approximate strength during 1930–39. Among the territories that remained occupied, breeding success was low in some districts, there being many nesting failures and an unusually high proportion of apparently unpaired birds. Only in the hills of the central Scottish Highlands was the situation normal, with most nesting territories still occupied and good breeding performance.

When decrease first became apparent, there was intense concern to understand the reasons for this unprecedented event. The speed and scale of decline were such that

a huge increase in death rate of adult Peregrines seemed certain to be involved. Suspicion quickly focussed on the new and highly toxic organochlorine insecticides, dieldrin, aldrin and heptachlor, which had been introduced as cereal seed dressings in agriculture around 1956. Because of their effectiveness, these chemicals gained rapid popularity and soon became widely used. Their use was equally rapidly marked by the widespread deaths of large numbers of grain-eating birds, from finches to pigeons and pheasants, on the fields where dressed cereals had been sown. The casualties also included kestrels, sparrowhawks, owls and foxes, which suffered secondary poisoning by feeding on both dead victims and birds still alive but loaded with residues of these highly persistent and therefore cumulative pesticides.

The circumstantial evidence, especially from the close correspondence in patterns of pesticide use and Peregrine decline, both geographically and in time, suggested strongly that this bird suffered the same effect. It took an elaborate research programme, spread over several years and involving numerous chemical analyses of tissues and egg contents, to establish a case for cause and effect, strong enough to convince the scientific community. In the meantime, the undeniable evidence of the farmland bird "kills" was sufficient to bring about Government restrictions on the use of the most toxic seed dressings for spring-sown grain by 1962. By the summer of 1964 it appeared that the Peregrine decline had halted, evidently as a result of this reduction in exposure to contamination. Numbers remained at about the same level for several years, but a repeat national survey in 1971 showed that recovery had begun.

At the end of 1966, the egg-breaking mystery fell into place at last. I had been convinced that the pattern of widespread breeding failure was all part of the pesticide syndrome, and finally began to measure and weigh old and recent eggshells to see if they could have become thinner. There was no change in eggshell size,

but the older specimens were markedly heavier, so they had evidently become thinner, and direct measurements of the shells confirmed this. By examining large numbers of shells in egg collections, it was possible to show not only that there had been a general decrease in thickness of about 20%, but also to date its onset precisely to 1946-47. This corresponded to the timing of the post-war release of DDT as a general insecticide.

It was quickly used to control external parasites on homing pigeons and so could quite directly have been taken up by Peregrines when they fed upon these birds. DDT then found widespread agricultural use, and its residues appeared in a high proportion of all bird tissues and eggs examined from the 1960s onwards. Experimental work by several scientists confirmed that DDT and its residue DDE are potent causes of eggshell thinning in a number of bird species. And the thinner eggshells explained the frequency of egg breaking and eating – which had by now been found in several other birds besides Peregrines.

During the following decade, further restrictions were placed on the use of the organochlorine insecticides, and most of them were banned under EC regulations in 1981. By that year, many districts reported strong recovery in Peregrine numbers, and the national population stood at about 90% of their pre-war level. The pattern of recovery reversed that of decline, with increase showing first in Scotland and northern England. A fourth countrywide census run by the BTO in 1991 gave a remarkable result. The overall population level was 145% of that in 1930–39: higher than at any time in the history of the bird. The increase was especially marked in inland districts, some of which had three times the number of breeding pairs ever known before. Coastal areas mostly showed lesser increase or none, and in both south-eastern England and northern Scotland numbers were still well below pre-war levels.

Continued monitoring showed that organochlorine residues in Peregrines had generally declined to low levels by 1981 so that this danger receded. The recovery of the population to its prewar status can thus be attributed mainly to the strenuous efforts made by the conservation organisations – especially the Nature Conservancy, RSPB and BTO – to have the most dangerous pesticides removed from use. The super-recovery to quite unprecedented numbers needs further explanation, however. The protection and educational campaigns for birds of prey run by the conservation bodies, especially the RSPB, were effective in reducing the persecution of Peregrines and ensuring that this did not once more create a severe drain on the population. The high output of young and good survival of established breeders created a surplus of recruits which established nesting places in many places once regarded as marginal or unsuitable for the bird. Many small rocks or even broken banks, with "walk-in" nest sites, in gently contoured moorland areas have become tenanted. There have been several recent ground nests, and use of old Raven tree nests is reported in two widely separated regions. Breeding falcons have occupied a large number of quarries, including many in active use, and new sites on buildings and other human constructions are reported every year.

Peregrines have thus shown themselves to be adaptable birds, not the least bothered by human disturbance when this is of a casual nature. Even on some cliffs where rock climbers are constantly present during nesting time, they have continued to occupy their favourite eyrie ledges, often successfully. More tolerant human attitudes and Peregrine adaptability can nevertheless explain only part of the recent increase. Perhaps the most remarkable feature of all is that numbers are now much greater in many areas where Peregrines appeared to be at a saturation density through their own territorial behaviour. In parts of England, Wales and the southern half of Scotland, many territories which were previously known to

be held by single pairs of Peregrines are now occupied by two or even three pairs. Since the strength of territorial interaction in this bird seems to be related to the abundance of available food, the apparent relaxation in such behaviour presumes an increase in food supply. There has been a considerable growth in the sport of pigeon racing over the last 20 years, and this could have provided just such an increase in falcon prey.

Whatever the combination of reasons for the present position, the Peregrine story of the years since Charles Tunnicliffe first captured the essence of its domestic life on the Anglesey seacliffs is one of welcome conservation success. It is doubly so, given that by the mid-1960s the most gloomy predictions for its chances of survival in Britain were being made. The birds had disappeared from the South Stack by 1962 and, although they were occasionally seen in intervening years, breeding was not reported again until 1977. Since then, nesting has been regular and usually successful in this ancient stronghold, now a reserve of the RSPB, where visitors can enjoy at first hand the excitement that Charles felt as he watched and sketched these sovereign birds.

Complacency in wildlife conservation is a dangerous thing, rather like tempting Providence. The horizon for the Peregrine is not without a few gathering clouds. Pigeon fanciers are once more growing increasingly hot under the collar about predation on their beloved homers. Some of them indulge in personal and illegal attempts at control, and there are growing calls for the removal of legal protection from the bird in certain areas. There is thus the irony that the wheel could turn full circle on the Peregrine story. Added to this are increasing complaints from grouse shooters that this species and the Hen Harrier are causing unacceptable damage to grouse stocks on some moors. There has undoubtedly been a renewal of illicit persecution by keepers in some areas, but the pressure to revoke legal pro-

tection is the most worrying trend. Egg collectors and falcon stealers continue to reduce breeding success in some areas, and would soon exploit any weakening in bird protection law.

So this book is a timely celebration of one of the most glamorous wild creatures that this country is fortunate enough to hold. The Peregrine population of Britain is the largest of the subspecies *peregrinus* in any European country, and a feature of international importance, of which we should be proud. Populations of various subspecies in many other parts of the world crashed as a result of pesticide effects, and even became extinct locally, as in the eastern United States. Britain led the way in seeking out the causes of the declines and in promoting measures for recovery. While other countries are also reporting recovery, none has yet shown such a spectacular comeback in Peregrine population. Having won this victory – and not without a good deal of strife with the agro-chemical industry and the agriculture departments – we are not going to give it up lightly. The Peregrine story here is a tribute to the dedication of all those many falcon enthusiasts whose information from field survey has made it possible to record understand and influence the trend in events in such detail. I trust that the captivating pictures in this book will help to add to the number of Peregrine fans whose support can be called upon in future if necessary.

D. A. Ratcliffe

25 November

1995

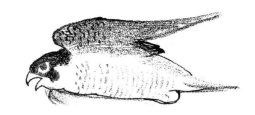

SELECT BIBLIOGRAPHY

Books by C.F. Tunnicliffe

My Country Book, The Studio, 1942
Bird Portraiture, The Studio, 1945
Mereside Chronicle, Country Life, 1948
Shorelands Summer Diary, Collins, 1952

Books featuring sketches and artwork by C.F. Tunnicliffe

Tarka the Otter, Henry Williamson, Putnam, 1932
The Peregrine's Saga, Henry Williamson, Putnam, 1934
A Sketchbook of Birds, Gollancz 1979
Portrait of a Country Artist, Ian Niall, Gollancz, 1980
Sketches of Bird Life, Gollancz, 1981
Tunnicliffe's Birds, ed. Noel Cusa, Gollancz, 1984
Shorelands Winter Diary, ed. Robert Gillmor, Robinson Publishing, 1992

Book of special interest

The Peregrine Falcon, Derek Ratcliffe, Poyser, 2nd Ed. 1993